IMAGES
of America

BATAVIA

FROM THE COLLECTION OF THE
BATAVIA HISTORICAL SOCIETY

D1205171

IMAGES *of America*

BATAVIA

FROM THE COLLECTION OF THE
BATAVIA HISTORICAL SOCIETY

Jim and Wynette Edwards

ARCADIA

BATAVIA LIBRARY DISTRICT
BATAVIA, ILLINOIS

Published by Arcadia Publishing,
an imprint of Tempus Publishing, Inc.
3047 N. Lincoln Ave., Suite 410
Chicago, IL 60657

Printed in Great Britain.

Library of Congress Catalog Card Number: 00-108010

For all general information contact Arcadia Publishing at:
Telephone 843-853-2070
Fax 843-853-0044
E-Mail sales@arcadiapublishing.com

For customer service and orders:
Toll-Free 1-888-313-2665

Visit us on the internet at http://www.arcadiapublishing.com

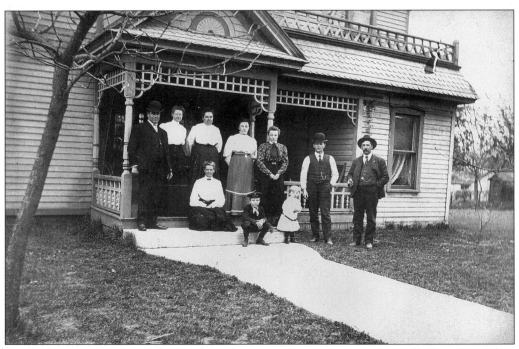

Pictured are, from left to right: (back row) Quincy Parre, Mrs Geiss, Hannah Downing, Clara Parre, Art Downing, and Frank Hooku; (front row) Ella Parre Hooku, Louie Parre, and Edwin Parre.

CONTENTS

ACKNOWLEDGMENTS

The Batavia Historical Society was expanding into the new John Gustafson Research Center while we were working on this book. The staff and volunteers of the Society were very thoughtful and helpful to us even during these difficult days for them. We thank them all for helping us compile this book.

We also thank and acknowledge those who have written about the past days of Batavia whose work we have consulted: Waite and Frank Joslyn, John Hamilton-Dreyden, Mark Johnson, John Gustafson, Roberta Campbell, Jeff Schielke, and Marilyn Robinson. Thanks to all of them for taking the time to track and record the daily history of Batavia. Next, we want to thank the unsung heroes who unselfishly donated their precious momentos and photographs to the museum for the public use. Without these contributions, this book could not have been written.

A special thanks goes to Jim Hanson for giving us the push to begin the project and to Bill Wood and Bill Hall, who helped sort out all the whos, wheres, and whens of old Batavia. Both the Batavia Public Library and the Aurora Public Library were of great help to our research.

We dedicate this book to the people of Batavia and all who love to read about the past, especially two members of the "Senility Club."

INTRODUCTION

The *Britannica World Atlas* lists three towns called Batavia. They are Batavia, Argentina; Batavia, Surinam; and Batavia, New York. This book is about none of these. It is a colorful pictorial glimpse of Batavia, Illinois, located in Kane County. The town is on the banks of a flowing body of water named after one of the original area's inhabitants, the Fox Indians.

In many ways, Batavia was much like the other communities settled in the 1830s throughout the Midwest. It is located near rich natural resources-flowing water, an abundance of trees, and rocks for quarrying. Batavia's first settler saw the last of the great Indian tribes disappear into the western sun, heading for a new life on a land where the grass was not green and the rivers did not flow as they did in Illinois.

The attraction was land for the white settler, who mainly came from countries and areas of the United States where good farm land was becoming scarce. The land in Batavia at the "Head of the Big Woods" was rich and inexpensive.

Railroads would also play a big role in the development of Batavia. By the time of the Civil War and into the 1880s and 1890s, railroad lines began to crisscross the continent through Chicago and a 60-miles radius. Batavia fell within this gridwork, and some lines were on each side of the river. They also led into Chicago which, by this time, depended on goods that were being shipped from the Fox Valley to meet the needs of their ever-expanding metropolis.

Each days hundred of railcars headed into Chicago from Batavia and the Fox Valley with farm products and limestone, which would help rebuild the wooden city of Chicago after the great fires of 1871 and 1873 as a city of stone.

Immigrants from all over the world came to Batavia to seek their destinies as farmers, businessmen, or laborers in the city's many factories. Batavia became more than a source of raw materials for others to use in their industries, it became a direct marketer of what every farmer on the Plains needed in order to increase their productivity—the high tech windmill. Batavia's three busy, large windmill manufacturers earned the city the nickname of "Windmill City." Irish, Germans, Swedes, English, and people of other nationalities headed for the factories of Batavia. Those in town who had money to rent farmland and build the factories profited the most.

In the last two decades of the 19th century, competition and mass production forced consumer prices to drop. Laborers saw lower prices and a shorter work week as an opportunity for them to engage in more leisure time activities. Batavians were ready to go to Laurelwood Amusement Park in town more often, buy an extra handful of John Geiss's excellent 5¢ cigars from his factory and store in downtown, or attend performances at Batavia's own opera house on the banks of the Fox River.

Times were good. Everyone seemed to have a job, and settlers who migrated into the community were welcomed, even if they were runaway slaves. What developed in this small community on the banks of a river in Illinois was something rather unique for its day. Skin color, language, and culture was not as important as who you were, how you worked, and whether you were a good neighbor.

The city had churches and individuals who worked passionately to rid the country of the plague of slavery early in the struggle, and they worked within a relatively new political party, called the Republican Party, which was in agreement.

The selection of the cover for this book was chosen to illustrate that Batavia was full of citizens who were working toward making racial differences potential assets rather than potential liabilities for the community.

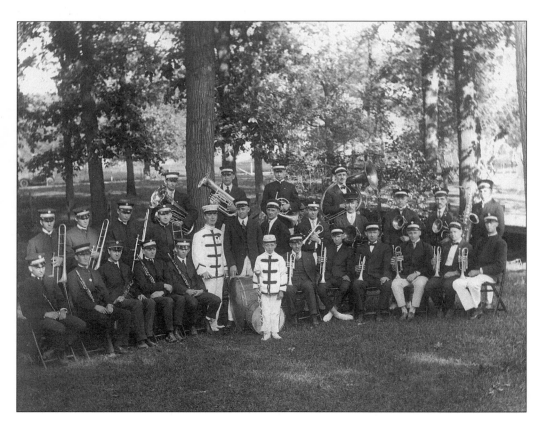

One

FIRST ON THE LAND

Nature provided the raw materials needed by the early Batavia setters to survive and flourish, just as it had for the Indians who had been disposed of in the Blackhawk Wars. The river was a source of food, and the water itself, when frozen, was Mother Nature's way to keep food from spoiling in the summer time. Ice harvesting in the winter, and the storage of that ice, became a major seasonal business for Batavians. Wood was also harvested to build homes and businesses. Soon choice lumber was used in Batavia to build much-needed wagons for those who began the settlement of the prairie lands and California. To make a wagon, one needed certain cast-metal parts. This meant that a local foundry needed to be constructed. Castings from this factory helped to reconstruct Chicago after the fires of 1871 and 1873. Each new business or settler who came to town necessitated more business and laborers. The town began to take shape with hotels, butcher shops, shoe stores, and dry goods stores. Batavia was on its way to becoming a city, not simply a village. Good Batavia magnesia limestone, another one of Mother Nature's gifts, became the basic building block for the "new Batavia," as well as the new buildings going up over night in Chicago throughout the past part of the 19th century. Batavia became known throughout the land as "Rock City."

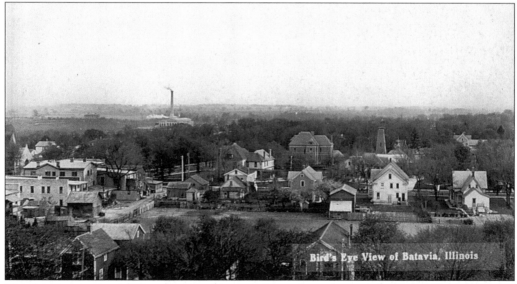

This bird's-eye view of Batavia is looking southeast from the steeple of the Congregational Church on Batavia Avenue in the early 1900s. What looks like a bridge is an alley way. The church on the left is Calvary Episcopal Church, also on Batavia Avenue. The camera distorts the angle to make it look as if it is east of the avenue. You can see the smoke stack of the power plant in the background. The large house is the Wade House, complete with its windmill tower.

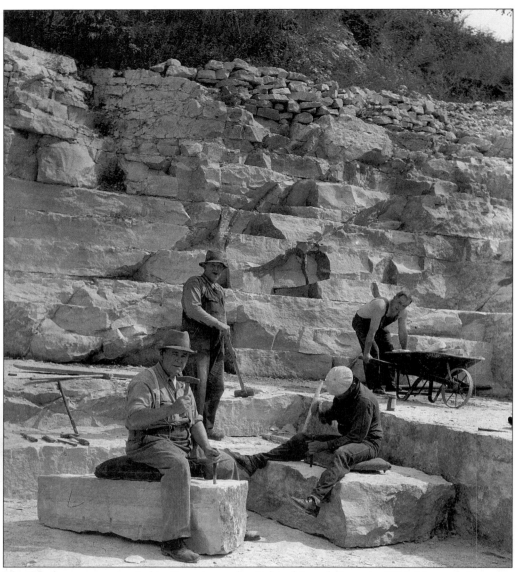

The first limestone quarried in Batavia was by Colonel Joseph Lyon in 1834. He used the stone to line a well. In 1842, Zerez Reynolds opened the first commercial quarry. By 1860 there were at least ten quarries in Batavia. In these early days, the rock was dug out of the ground with shovels and chisels. Workers from Hendrickson's Quarry in 1927 are pictured above using hand tools to dress the stone.

By 1887, L.P. Barker operated the largest quarrying operation in Batavia. The stone from this quarry was used to build the Chicago and Northwestern bridge in Geneva. Most of the Challenge Company buildings, and the first buildings at Northern Illinois University, were also built of stone from this quarry.

The land that the Barker quarry stood on was purchased by Frederick H. Beach and donated to the township park board in 1920. This land was the site of a Works Progress Administration public project to fashion a park and pool, both of which are still favorite summertime places for the children of Batavia.

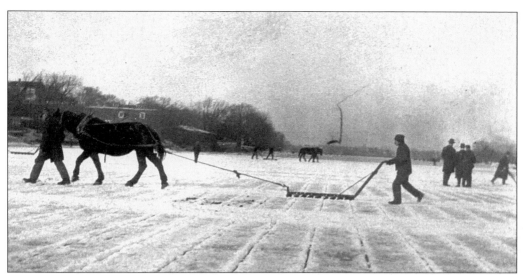

There were many ice houses along the Fox River. Before the days of electric refrigeration, ice harvesting was a necessary river town industry. Thousands of cars of ice were shipped out of Batavia each year. The area from which ice was to be harvested was cleared of snow. A man with a marker, drawn by a single horse, marked the field both ways about 24 inches apart. Marking was followed by a plow, which was a flat blade with coarse teeth on the bottom and steered with two plow handles.

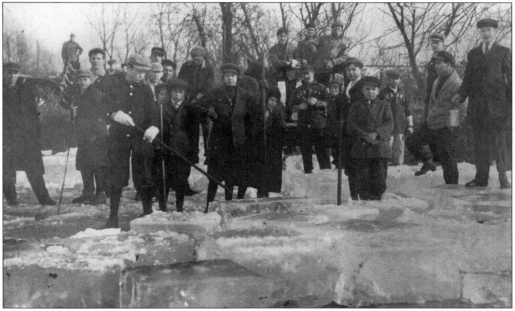

Two block sizes were harvested, one for large ice boxes of the meat markets and saloons, and the other for home ice boxes. After the ice cakes were separated by a plow or by hand, depending upon the depth of the ice, men with long-handled chisels pried the cakes loose. Others guided the chunks with pikes to the storage facility elevator, where they were lifted and slid into place. Harvesting continued until the ice house was full, or until the weather turned too warm to harvest good ice.

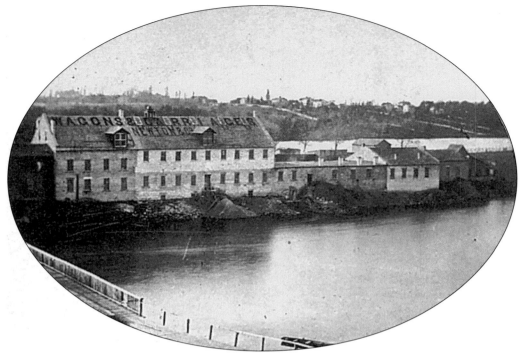

Levi Newton came to Batavia in 1854, after fire had destroyed his New York wagon works. Wanting to be close to his western customers, Newton found a good water source in the Fox River and hard wood timber in the Big Woods. He and his son, Don Carlos, first built a raceway for water power, then the wooden factory included a blacksmith shop, a wood working shop, a paint shop, and an office. Fire leveled this building in 1872, but the Newtons once again rebuilt, this time with limestone.

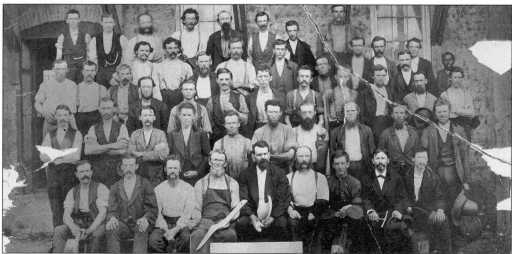

During the first year, 36 wagons and 35 buggies were turned out. At their peak, over four thousand wagons were built per year. This photograph of Newton Wagon employees was taken between 1874 and 1888. The only employee identified is H.B. Schuldt, located third from the left in the second row. Some of the men are holding parts or tools used in wagon making.

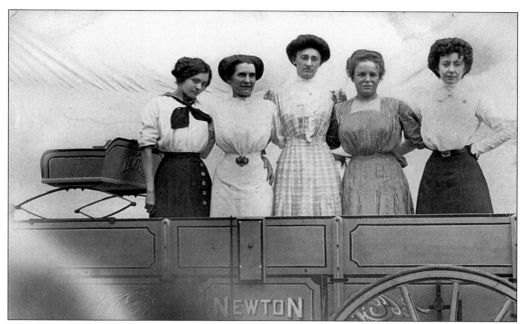

In the beginning, when Newton needed seasoned lumber for wagons, he bought a Batavia west-side log cabin and used the logs to make wagon hubs. This picture may have been of a group of later employees, or an ad for Newton wagons.

Newton wagons became known for their strength and durability. Many were sold to be covered with heavy, white cotton over strong bows for the western trek of the pioneers. This company hoisted a wagon to the roof to advertise their stock of Newton wagons.

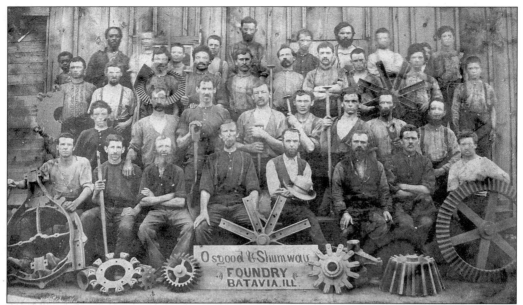

C.W. Shumway & Sons Foundry began business in 1872. Charles Osgood became a partner in 1875. In the early years, the factory produced all kinds of iron castings to reconstruct the Chicago buildings and machinery lost in the recent fire. These employees are shown here with some of the goods they helped produce.

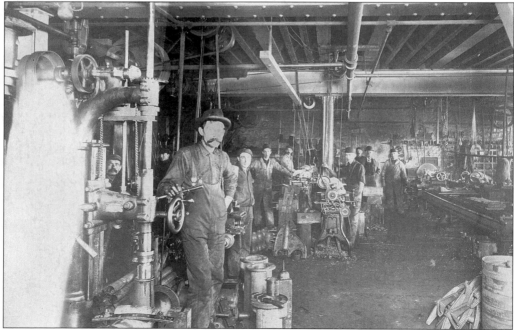

Work was performed using water and man power, not machine power. The process has remained much the same for hundreds of years. The main ingredients used are iron, sand, and fire. In addition to iron castings for new Chicago buildings, the foundry produced hitching posts, flat irons, trolley car gears, and pulleys.

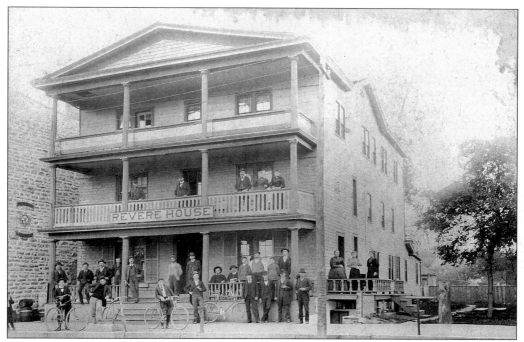

The Revere House, an early hotel, was located on South Batavia Avenue. This hotel may have been the finest of the Batavia hotels. It was a gathering place to discuss the issues of the day as well as a social meeting place. Visitors who stayed in the Revere House could see across the river valley from the three galleries across the front.

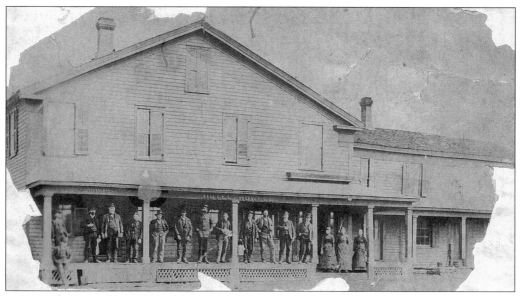

In 1870, the Howell Hotel was located on the northeast corner of Van Buren and Webster. Mr. Howell is standing third from the left. Mr. Howell's daughter is the first woman on the left, and Mrs. Howell is the second. This hotel was near the depot, making it convenient for rail passengers.

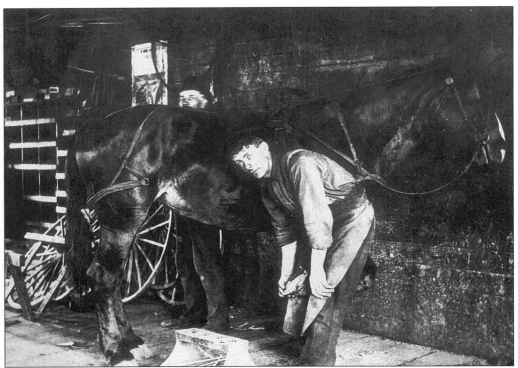

In 1850, there were 15 blacksmiths pounding away in Batavia. By 1920, only four were still working the trade, one of which was a Wenberg who was located at the northeast corner of River and State Streets. Pictured here is Charles Wenberg Jr. shoeing a horse in the early 1900s.

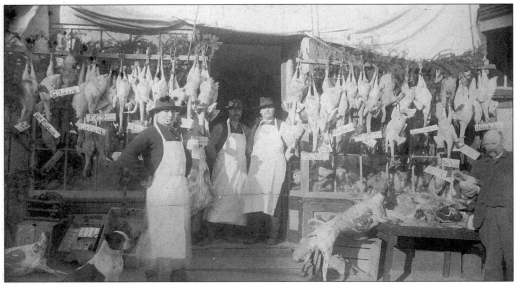

Nels Benson's meat market was a typical meat market of the day. Meat was butchered daily and to order. Notice that the hanging birds are without feathers but still have heads and feet attached, and each is tagged with the customer's name. Benson's meat market was located on South Batavia Avenue.

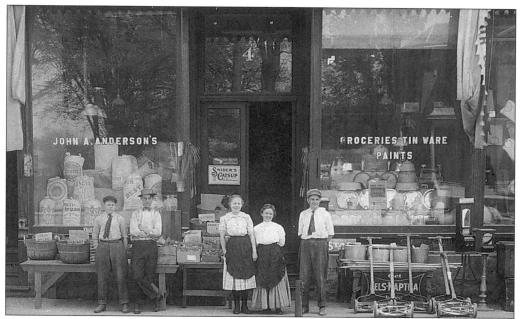

Oscar and the first John Anderson were merchants from the time they settled in Batavia. Their establishment was the place the Swedes in town came to visit and shop. This John carried on the family tradition. Pictured from left are: Ralph Swan, unknown, Margaret Elfstrom Bergstrom, Eva Otterstrom, and unknown in front of John Anderson's store.

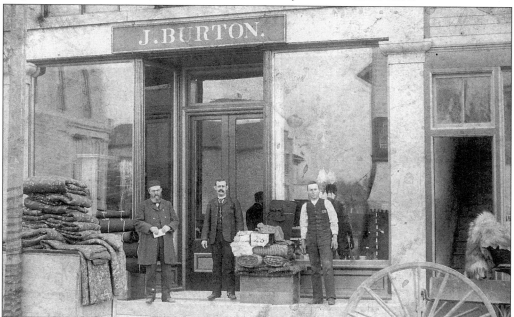

Joseph Burton sold dry goods on the south side of East Wilson near 11 River Street. Pictured are Joseph Burton, Tom Burton, and Arthur Broughton in 1888. Burton was born in Yorkshire, England, and came to Batavia in 1852. He worked as a grocer, in time adding dry goods, and still later providing a tailoring service within his store.

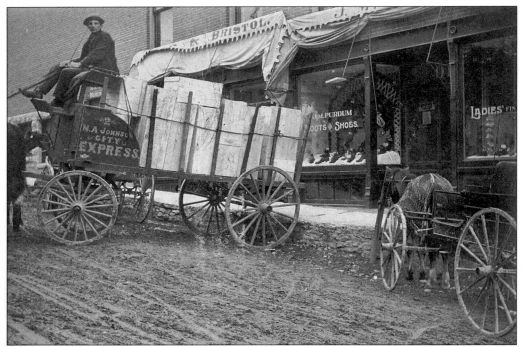

John M. Purdum operated a shoe store at 91 Wilson from 1885 to 1905 in the lower level of the Anderson Block. He was also one of Mrs. Newton's coachmen for a year. This delivery man is pulled right up to the front door to unload. We see here that parking wasn't as strict then as it is now.

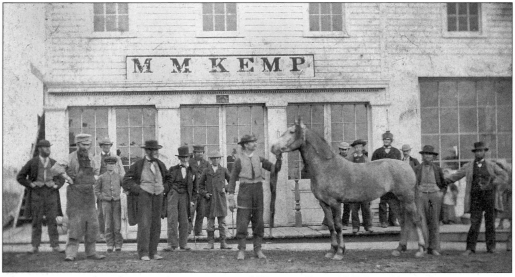

This retirement day photograph was captioned "Batavia Days 1868," and lists who was present, but not in a recognizable order. Milo M. Kemp was in the hardware business with his brother William E. Kemp. This location was later the home of Hubbard's and earlier the home of the first Congregational Church building. The Batavia High School basketball team also played their home games in the building until a gymnasium was built.

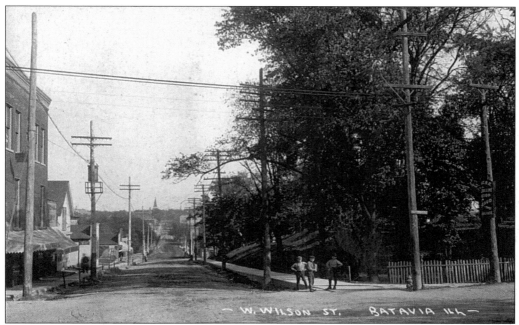

This view of Wilson Street from Batavia Avenue was taken around 1900. On the left is the northeast corner of the Anderson Block. Next is the Burton house. The trees on the right are part of the John Van Nortwick estate. The steeple in the background if that of Holy Cross Catholic Church.

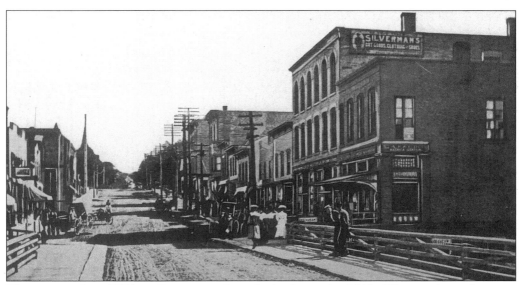

This view is also of Wilson Street, east from the bridge in the 1890s. The wooden railings are on a stone bridge, the only bridge in the Fox Valley to withstand ice break-ups in the spring. On the right (south side) is the Thomle building furniture store. Next is Litgens Grocery Store, Geiss Cigar Store, Ed Young's bakery, and Oscar Brenner and his father's dry goods store. The large stone building on the corner housed the Merideth Hardware Store.

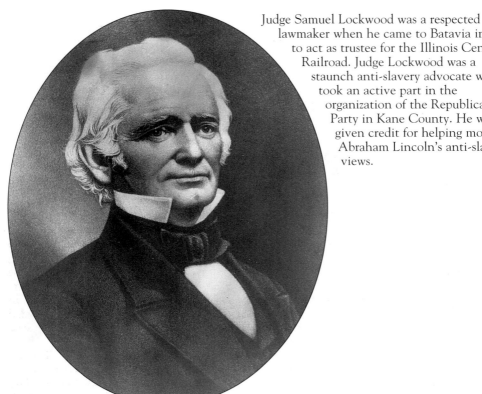

Judge Samuel Lockwood was a respected lawmaker when he came to Batavia in 1853 to act as trustee for the Illinois Central Railroad. Judge Lockwood was a staunch anti-slavery advocate who took an active part in the organization of the Republican Party in Kane County. He was given credit for helping mold Abraham Lincoln's anti-slavery views.

John Van Nortwick and his father, William, came to Batavia in 1836 or '37. He built one of the first dams across the Fox and erected a sawmill. His empire eventually also included the Batavia Flour Mill, the Batavia Paper Co, and the US Wind Engine and Pump Co. He was also a consulting engineer for the C&NW and CB&Q railroads.

Two

CITY OF ENERGY ENTREPRENEURS

Passed in 1862, the Homestead Act started a manufacturing revolution in the United States which would benefit Batavia industries and make their owners wealthy beyond their wildest dreams. Under the terms of that act, all heads of families and all males over the age of 21 who had not borne arms against the government were entitled to file claim on 160 acres of land in the public domain. He could perfect his title in either of two ways: by living on it, cultivating it for five years and making some improvements in the way of house and buildings; or, by living on it for six months, making trivial improvements, and paying the government $1.25 per acre. By the end of 1865, more than 150,000 people had laid claim to almost 2.5 million acres. In the years following the Civil War, those numbers increased tenfold, and every farmer needed at least one windmill, in addition to plows, planters, mowers, manure spreaders, and other farm tools. Wind power was virtually a free source of power for the farmer.

Batavia factories wanted to manufacture windmills and water storage tanks for all these homesteaders. Batavia had three windmill factories, and became a leader in windmill production for the entire nation. The competing factories used cutting-edge technology for making their products cheaper, better made, efficient and longer lasting. They developed sophisticated hard-sell advertising to market their goods. Windmill manufactures acted as a catalyst in drawing foundries and other small manufacturers of the sub components of windmills to Batavia. Having a railroad in town helped put factories in Batavia and helped keep industrial growth heated up.

The Batavia Power Plant, built in 1901, became the heart of an interurban electric line that could transport Batavians into and out of the city of Chicago at the incredible speed of up to 70 miles-per-hour. The power plant depended on another natural resource of Batavia, water. The plant used about 5 million gallons daily of Fox River water to run its boilers.

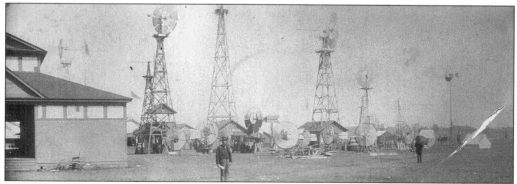

Fourteen different windmills of the Challenge Co. are shown in this trade show display. At the 1893 World's Fair, the Challenge Co.was said to have presented a greater variety of windmills, fixtures, attachments, and uses than could be found in Europe. Challenge came to be one of the largest and most prosperous American windmill manufacturers in the second half of the 19th and first half of the 20th centuries.

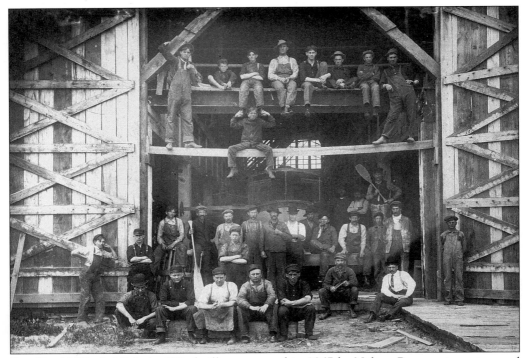

Burr Feed Mills & Nicholas Windmills was started in 1867 by Nelson Burr, an inventor, and Hugh Armstrong to manufacture feed mills. The first year there were two employees, and by 1871 there were between 30 and 50. After financial difficulties and a fire in 1872, the company was reorganized as Challenge Mill Company. By the mid-1880s, the company was producing two thousand windmills a year, as well as small farm equipment.

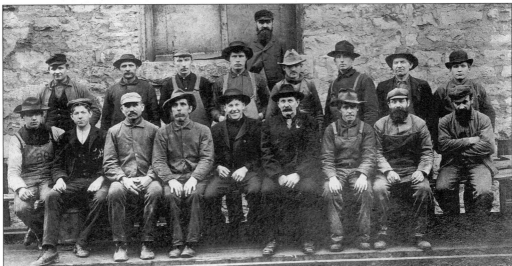

Shown here is part of the Challenge work force in the early 1900s. Walter Dickenson was the foreman of Challenge Co. from 1920 to 1932. His son George told the Batavia Historical Society of playing around the factory as a young boy. "Once in a while we would open the doors to look inside the foundry, but we couldn't do it for long because. . . it was too hot and smoky."

Challenge Double Header Power Wind Mill

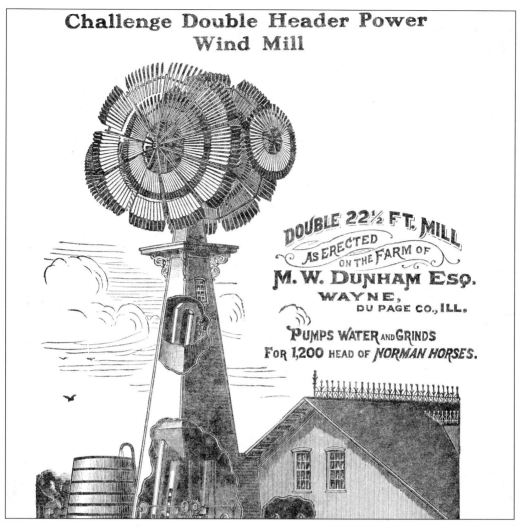

DOUBLE 22½ FT. MILL
AS ERECTED
ON THE FARM OF
M. W. DUNHAM ESQ.
WAYNE,
DU PAGE CO., ILL.

PUMPS WATER AND GRINDS
FOR 1,200 HEAD OF *NORMAN HORSES.*

This ad for the Challenge double-header power windmill was accompanied by a letter of recommendation from Mark Dunham of Wayne, IL. In it he wrote, "I consider it the very best made, or I would not have bought it at any price, and I have had no occasion to change my opinion thus far. When I bought the first Challenge Wind Mill, in 1869, for pumping water, I soon found it superior to the kind I had been using, and since that time I have bought three or four Mills of your make, and placed them on my different farms, and they always gave, and do yet, the best of satisfaction. But before buying a Geared Wind Mill, for grinding and shelling, as well as pumping water, for my large lot of imported Percheron horses, I thoroughly investigated as to the merits of the various makes of Wind Mills, and although I found others that could tell a better story than you did in regard to their mills, yet I found their mills in actual operation, in comparison with yours, were nowhere, and actually found your mills doing very much more work than you claimed for them. This, in connection with your strong printed warranty in catalogue, and knowing you to be responsible fore its fulfillment to the letter, decided me to place my order with you, and I must say that I am *dissatisfied*—dissatisfied with myself that I had not got one years ago. . . . The power in it is simply immense, and does seem almost incredible. It runs two large double-acting pumps, six inch diameter cylinders, twelve inch stroke."

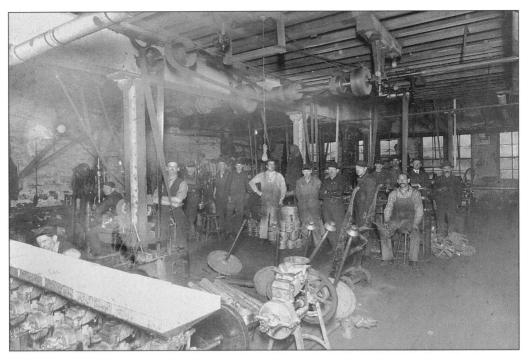

Challenge not only built windmills but also built pumps, feed grinders, shellers, feed cutters, and tanks. They claimed to manufacture a larger line of goods than any other industry. These are employees of the machine shop in 1911 hard at work keeping inexpensive farm tools available for farmers.

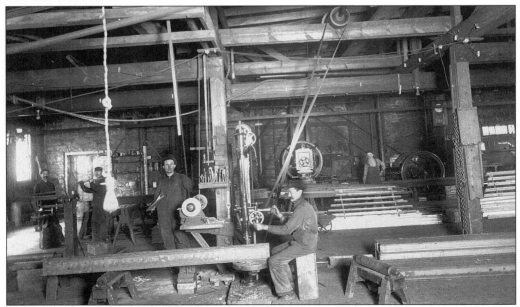

Water power from the river was the main power source for machines such as the one shown here in the galvanizing room. Notice how the drill could be moved across the beam as the man worked. Long shafts and belting transferred water power to run the machines.

The Dandy steel mill was a high-tech marvel. It was featured in the Chicago World's Fair and thought to be the best of the windmill displays. At 100 feet, it towered over all the other displays. The Dandy featured graphite bearings that never needed oiling, a great labor-saving device for the day.

Early on, Burr produced the Challenge sectional wheel, designed to include a vaned wooden section where there was a rigid vane to keep it facing the wind. The Challenge 27 was introduced in 1927, and it quickly became the most produced of all the Challenge windmills. Challenge had branches in Minneapolis, Minnesota, and in Lubbock, Texas. Windmills were shipped via the Chicago Northwestern Railroad to these branches. After farmers were hooked up to electric companies, the windmill demand lessened in the Midwest, but was still a big part of the company's business, mostly in the southwest and western parts of the country, as well as in Australia and South America. A later version of the Challenge 27 is part of the windmill display near city hall today.

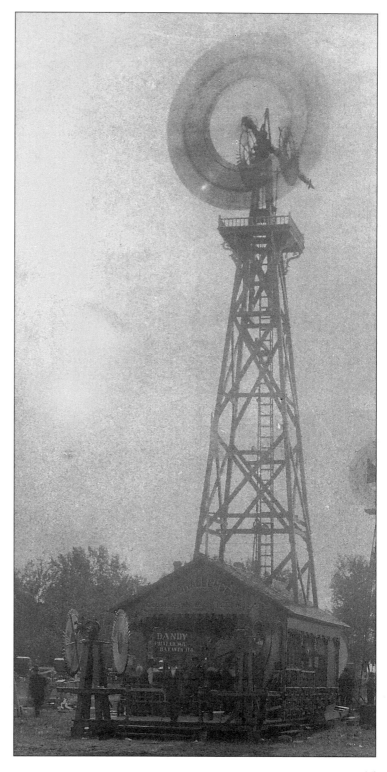

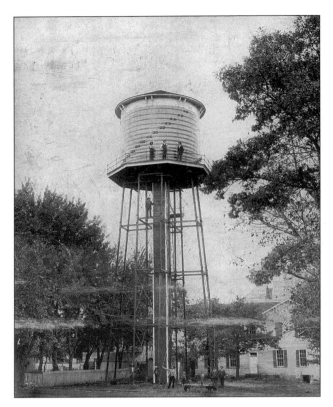

Large wood water tanks were sold mainly to companies and to municipalities for water storage. Railroads also needed water tanks for their steam locomotives. Cypress and redwood were the main woods used for staves and other wooden parts in the early years.

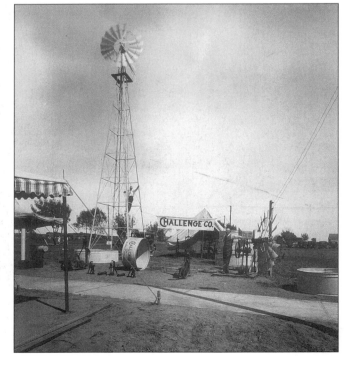

This Challenge ad shows several of the 107 different sizes and types of mills produced by the company. There was fierce competition in town between Challenge and United States Wind Engine & Pump Company prompting the title "Windmill City" for Batavia, which stuck far into the twentieth century.

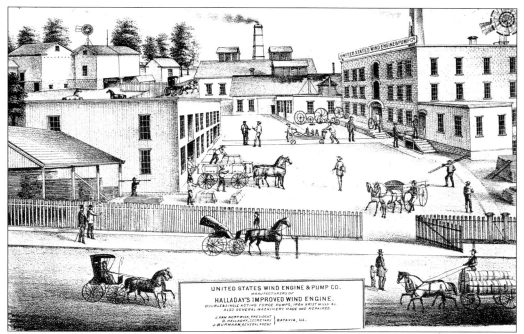

Daniel Halladay invented the first commercially successful self-governing American windmill in 1854. These windmills were self regulating to fold themselves up to resist a storm or turn in every direction to catch the slightest breeze. At the request of John Van Nortwick, he moved his windmill operations to Batavia in 1863, and reorganized under the name United States Wind Engine & Pump Company.

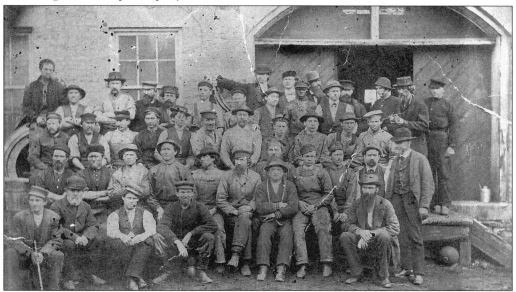

United States Wind Engine & Pump was the first to manufacture windmills in Batavia. In 1887, it was the largest windmill producer in the country, and in its prime the company employed more than two hundred men. Their windmills, pumps, and other machinery were shipped all over the world.

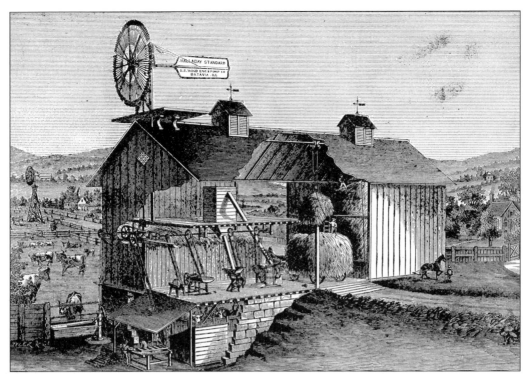

This advertisement is for the Halladay standard geared wind mill. The text reads, "10 sizes, 12 to 30 feet diameter, 1 to 8 horse power. For Farm and Dairy use. A cheap power for driving Corn Shellers, Feed Mills, Elevators, Straw Cutters, Threshing machines, Circular Saws, pumps, Etc." USWE&P conveniently also made many of these "modern conveniences" that the wind mill could run as well.

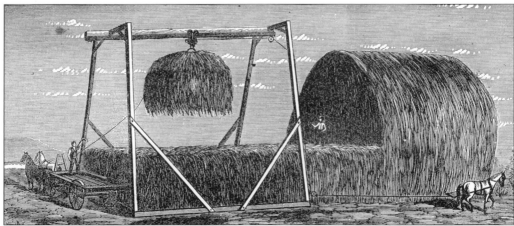

This advertisement for the Noyes field pitching apparatus shows the variety of the company's products. It is claimed that 5 tons of hay was moved in 45 minutes. It was also claimed to be better than stacking by hand, because the hay is dropped in the middle of the stack and becomes packed hard and high to shed water, the stack will not lean, and three times as many wagons can be unloaded in a day, so it won't be necessary to keep the stack open too long, and the hay is less endangered by storm.

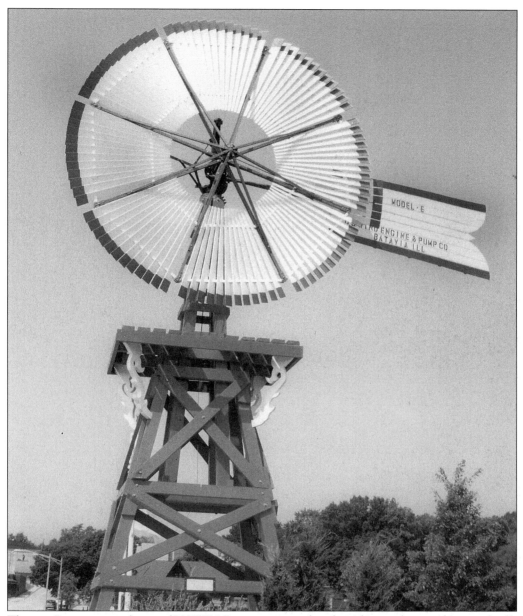

Thomas Perry, an employee of USWE&P, experimented with replacing the wood in windmills with parts made with steel. His first improvement was to replace the wood wheel with galvanized steel. He later also replaced the slats. The size of the wheel could then be reduced from 12 to 15 feet to 8 feet and still provide enough power for ordinary pumping purposes.

Perry also added a small side vane right behind the main vane, which would turn the wheel partly out of the wind when high winds were blowing. This reduced the surface exposed to the wind and cut down on the lost action. The company resisted Perry's improvements with steel even, according to hearsay, to the point of producing an inferior steel mill. This effort was said to have cost the company its reputation until it began to produce good steel windmills. Perry eventually left USWE&P to form yet another windmill company, Aeromotor of Chicago.

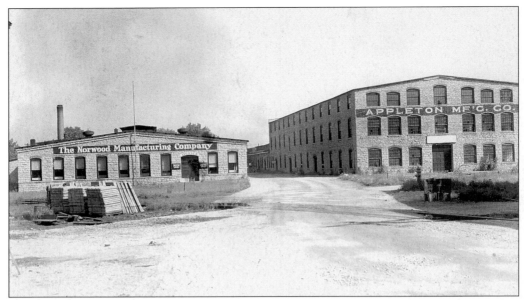

The third major windmill maker in Batavia was the Appleton Company, which was started in Appleton, Wisconsin, in 1872. William and John Van Nortwick purchased controlling interest and moved the plant to the town of Van Nortwick, just north of Batavia. This plant was destroyed by fire in 1900. The Batavia Business Men's Association persuaded the Van Nortwicks to build the replacement plant in Batavia.

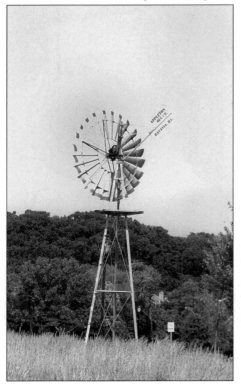

The new Batavia plant had 150 employees in 1900. In addition to windmills, they manufactured manure spreaders, corn huskers, and wood saws. If you look closely at this photograph, you can see the curve of the steel slats with the concave side to the wind. The setting of the slats at exactly the right angle was very important to a properly running windmill.

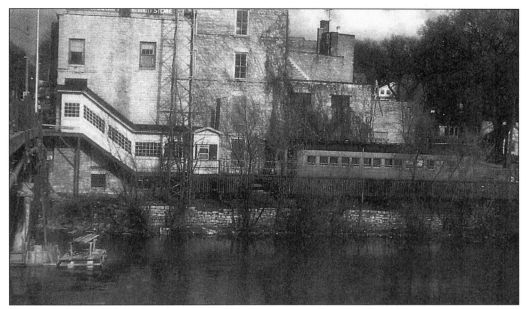

Here is a photograph of the electric line car coming into the downtown Batavia station, which was located just off Wilson Street. Passengers going upriver from Batavia had to get off, cross the river, and get on the train on the west side of the river.

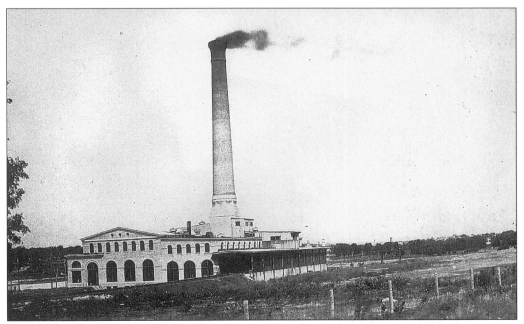

In 1902, the Chicago, Aurora, and Elgin electric railroad was completed. This line brought Chicago excursionists to Glenwood, Laurelwood, and Mill Creek parks, and took Batavians to Chicago for work, shopping, and sightseeing. It was known as the third rail. The power plant building was constructed of Batavia limestone with a stack that was 240 feet tall.

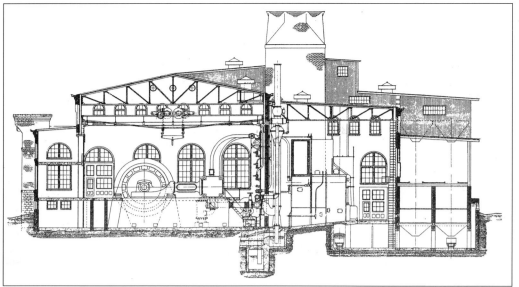

This cross section schematic of the power house shows one of the four generators along with its mammoth 2,200-horsepower engine. There were eight 500-horsepower boilers with 5 million gallons of water used daily to power the entire system.

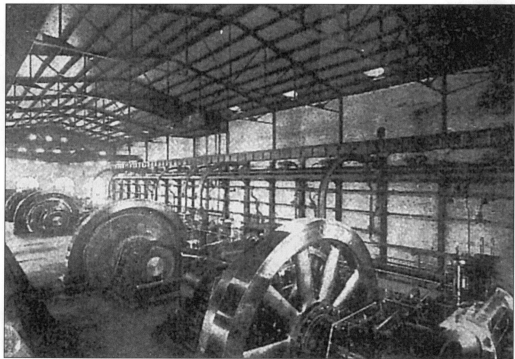

This is the interior of the power house with its four generators. When the electric line system was abandoned over 50 years later, some of the old CA&E cars were taken to railway museums in South Elgin and Union, Illinois, for display, restoration, and eventually rolling stock open for rides.

Three

THEY CAME TO LIVE AND SERVE

Batavia was a destination for all sorts of people from foreign lands, the eastern seaboard states, and the south in the latter half of the 19th century. Blacks made their way into the community from the south as either freedmen or runaway slaves. The first recorded reference to the black population was made in 1860, noting that there were three black families living in Batavia. These 25 blacks lived openly in the community, free from bounty hunters. This small community of blacks was joined during and after the Civil War by even more, indicating that Batavia was a safe and friendly place for settlement.

Blacks in the north, including those in Batavia, had to fight hard just for the chance to serve their country during the Civil War. Union armies refused to have blacks fight with them in battles, and the first action black soldiers saw when they were allowed into special units was in mess duty, gunnery crews, and other support roles. The State of Illinois was also reluctant to place blacks in white fighting companies, or constitute all-black units. This is understandable politically once you realize that there were thousands of citizens in Illinois who sympathized more with the south than the north in the war.

There were ten blacks who served to keep the Union intact by becoming soldiers of freedom and who lived in Batavia after the war. Most fought in a national infantry unit called the United States Colored Infantry (USCI). Other Batavia blacks served with the 4th US Colored Heavy Artillery and the 14th Regiment RI Heavy Artillery. When blacks were allowed to take part in the war and bear arms, they fought with great distinction as separate fighting units. When those who served came home, they became respected members of the community and active members of the GAR Post 48. They returned to Batavia to become day laborers, factory workers, and owners of small businesses.

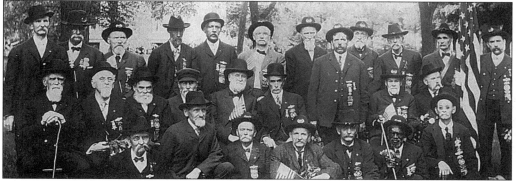

This is a gathering of Batavia's post of the Grand Army of the Republic (GAR) around 1909. John Ozier, one of the ten blacks who served in the war, is sixth from the left in the first row. Standing in the middle row, left to right, is Edwin Stafford, then H.K. Wolcott. Fifth in this row is J.G. Brown and next to him is W.J. Hollister. The first in the back row is Fred Morse, and the fifth from the left is James Stewart.

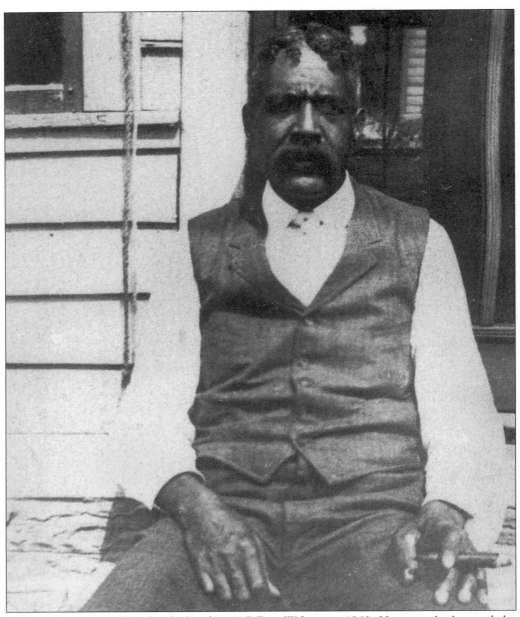

William Stewart and his family lived at 117 East Wilson in 1860. He was a barber and the father of three children, Sarah, Jordan, and James. Both sons enlisted in Company B of the 29th United States Colored Infantry. James, who returned to Batavia after the war, followed in his father's footsteps and became a barber. Holbrook photographed him in front of his shop.

As members of the USCI, both James and his brother Jordan fought in Texas and later took part in the tragic 1864 "Battle of the Crater" in Petersburg, VA. The USCI had been specially trained to be the vanguard unit to enter a secret tunnel dug underneath enemy lines, and plant gunpowder intended to blow up the fort. At the last minute they were replaced with white troops. Only after the first wave of white troops failed in their mission were they allowed to enter the tunnel and try to win the day.

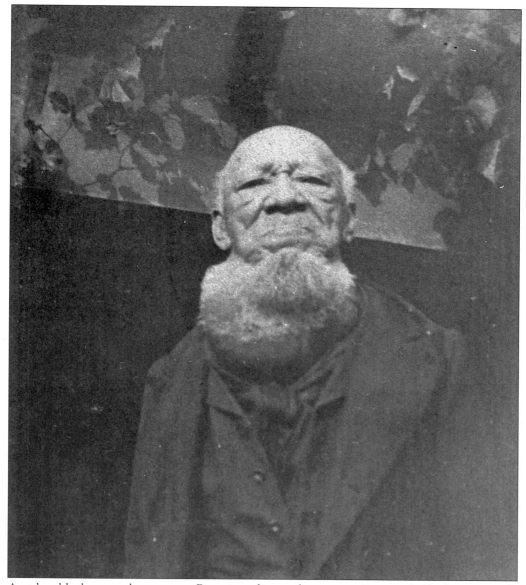

Another black man who came to Batavia to live and serve was Reverend Abraham T. Hall. Hall was born in 1822, and was married in 1846. He and his wife, Johnanna, had 11 children. One of his sons, Charles E. Hall, worked in the Census Bureau in Washington and was considered one of the most important black officials in town.

Before coming to Batavia in 1866, Rev. Hall had founded the Quinn Chapel in Chicago. Blacks in Batavia started to construct their own church in 1865, on the northwest corner of Logan and River Streets. Named the African Methodist Episcopal Church, Rev. Hall was to be its founding minister. The church was to continue until 1920. In 1922, another black church was built on Logan Street and called the Logan Street Baptist Church. About that time, the black community was expanding eastward to Latham, Park, Washington, and VanBuren Streets.

Reverend Hall was plagued with a huge goiter and died in 1916. One of his children moved to Aurora, and others to Minnesota, Pennsylvania, and New York.

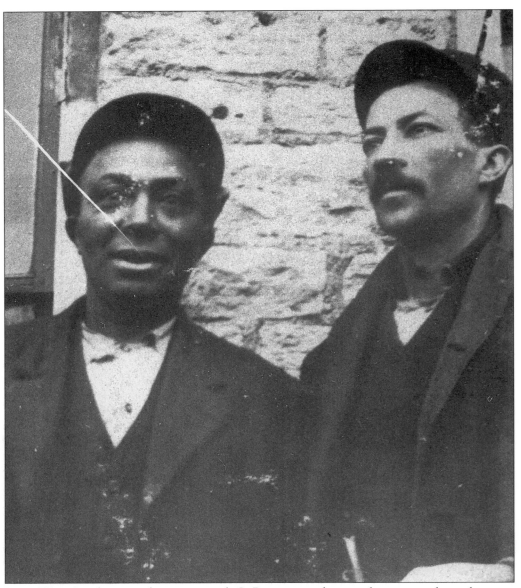

James Watts Jr., shown in this picture with O. Barton, was the son of a runaway slave who came to Batavia at the beginning of the Civil War. His father, James Watts Sr., decided to serve his country as a private in the 29th Regiment USCI. Watts Sr. was 36 years old when he joined, leaving behind a wife and three children. The pay was less than that of white soldiers. He received $10 per month, which was probably sent home to his family. Had he stayed at home, the pay would have been much better, even if he worked as a day laborer. James gave his life for his country, falling at the Battle of Fredericksburg.

James Jr. grew up without his father, and not much is known about what kind of job he might have had. There are references to him doing a lot of hunting and fishing, which may have been his profession. He lived in a log cabin on North River and Lake Streets with his wife, Juda, and their three children. He died in 1813, at the age of 49. Some members of the Watts family are buried in the East Batavia Cemetery but have no stones to mark their graves.

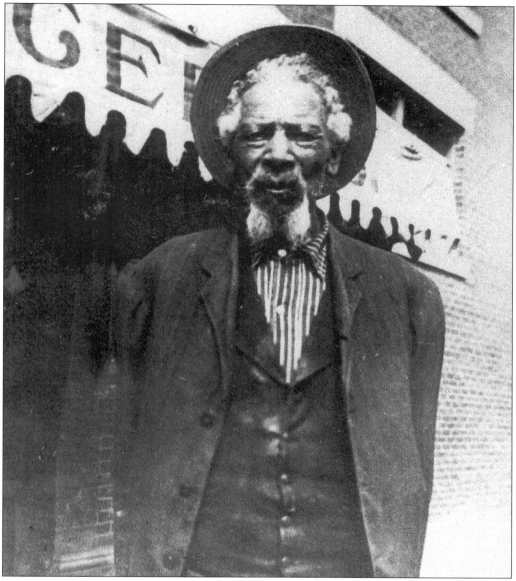

Steven Smith, shown here in front of the Geiss Cigar Store, was a runaway slave from a plantation in Kentucky. He escaped into the North by way of the Underground Railroad, which was not a railroad at all, but used railroad terminology such as "conductor" and "passenger" to help escaping slaves through a series of safe houses into the north and freedom. Even when supposedly safe in the North, a local sheriff or bounty hunter might turn them in for a cash reward. Illinois had a law in the 1850s that made it illegal for any freed black to settle in the state. The law seemed to have been virtually ignored in northern counties such as Kane. By 1860, there were 25 blacks living on North River Street, and many were escaped slaves. The growth of the black community before, during, and after the Civil War indicated that Batavia was a safe place for blacks to settle.

Smith, his wife, and three children lived at 109 Latham in Batavia. He served in the Civil Was as a member of the 4th US Colored Heavy Artillery, and arrived in Batavia after the war.

37

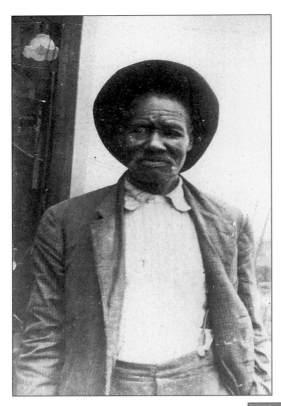

Clabern Turner was born in 1833 and had one child, Rosa May, who was born in 1870. He and his wife, Catherine, lived on Park Street. The family were members of Calvary Episcopal Church. His daughter was the first black female graduate of East Batavia High School. Turner gardened and took his crop to market, but he also worked as a janitor for the East Side School on Washington Avenue. He died in Batavia at the age of 95.

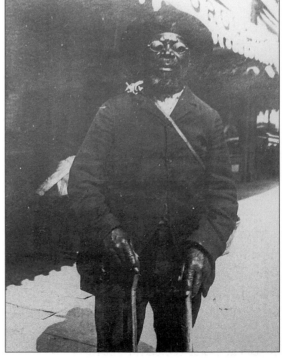

Another Turner captured by Holbrook's camera on the street of Batavia was James Turner Sr. In younger years, Turner was in charge of the paint shop at the Challenge Co. He and his family were active members of the African Methodist Episcopal Church. His son, Albert, also worked as a painter of windmills at the Challenge Co., but he took the summers off to tour with a singing group.

Other than two photographs, there is no information in the files of the Batavia Historical Society relating to M. Woldridge. This photo of him was taken around 1909, in front of one of Batavia's grocery stores. In another picture, he was shown crossing Wilson Street with a basket full of groceries. He may, therefore, have been a delivery man for the grocery store, or could have simply been a friendly customer.

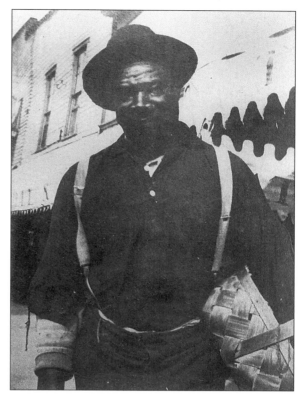

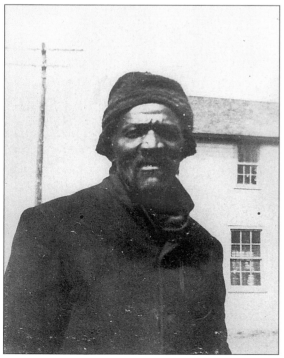

Jerry White lived on the northwest corner of River and Latham with his wife and family. White liked to work for "C" (Challenge Wind Mill Co.) employees, and for the local creamery. On the side, and later full time, he was a handyman, gardener, and a garbage man. Jerry White died at the age of 89 in 1935. (Photo is c. 1909.)

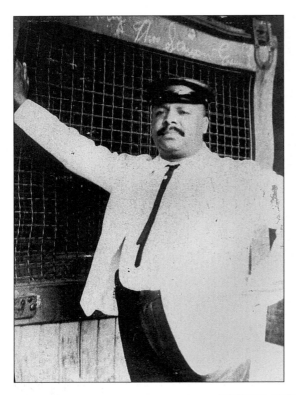

This striking picture is of B. Lippins who, judging by his dress, handled deliveries at the freight depot on the east side of town. Notice the caged storage area in the background of this c. 1909 photograph by Holbrook. Batavia's Judge Lockwood, who helped restructure the Republican Party and was a well-known opponent of slavery, must have been pleased with Batavia's opening up its town to so many escaped slaves and free blacks.

A house on Church Street was the home of Joshua Jackson and his wife, Jane. There were five children in the family by 1880. Joshua and his son Charles were barbers in town. One of his other children could have been the E. Jackson photographed outside a store in town. Jackson is wearing a shop apron, which may mean that he was employed as a clerk in the business behind him in the photograph.

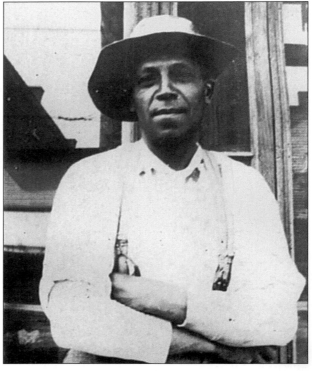

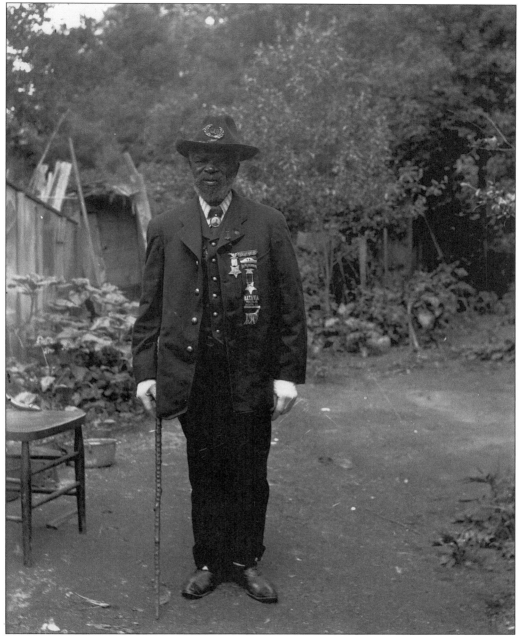

John Ozier is Batavia's most famous black settler who fought in the Civil War. He served with the 14th Regiment of the Rhode Island Artillery. He was born right before Christmas 1818, in Lowden County, Virginia, as a slave. In the course of his slavedom, he had three or four different masters. As was typical when slaves were traded, families were separated, and John was separated from his wife and child. John escaped his bondage in 1863, and made his way to Chicago where he enlisted. It was only in 1863, when the war was going badly, that the North, contrary to Lincoln's wishes, began to form colored companies. Ozier was mustered out of the Army on October 29, 1866, and returned to Chicago.

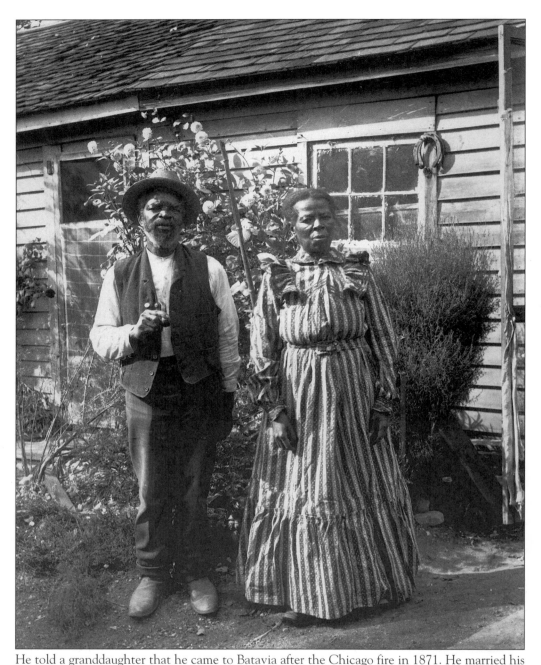

He told a granddaughter that he came to Batavia after the Chicago fire in 1871. He married his second wife, Annie, in 1867 and built a cabin in Batavia at the corner of River and Gore Streets.

John Ozier was a member of the Batavia Post of the Grand Army of the Republic, appearing proudly at parades and official gatherings. He was also a member of the Secret Society of Masons. In the late 1890s, John had a store just outside of Laurelwood Park, one of two large amusement centers built in Batavia by competing railroad companies. His shop featured candy, tobacco, and a general line of tourist goods. This postcard of him with his wife outside their log house surely sold well to the visitors at the amusement park.

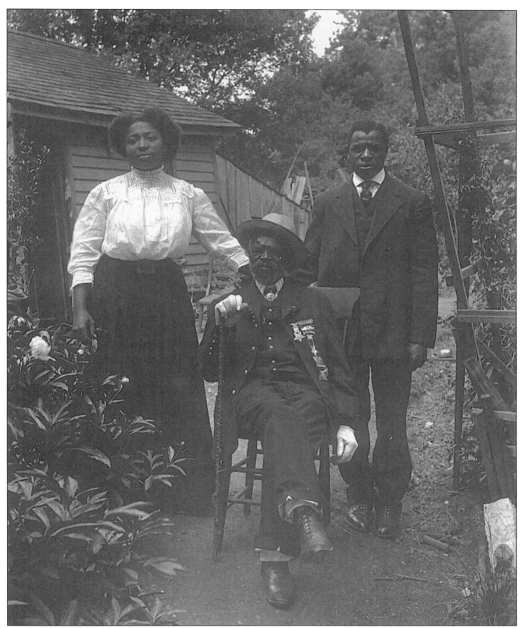

Once he had established himself in Batavia and built enough rooms onto his simple one-room house, Ozier sent for his daughter, Lena. Lena was married to Jerry White and had two children. Lena and Jerry are shown here with John. John lived to be very old, dying in his 100th year. His beloved second wife died in 1908. In his declining years, he was taken care of by Hattie Lloyd and his grandson, Fenlen White.

In those hundred years, John Ozier had seen some of the most dramatic moments in all of American history. The Mexican War, Civil War, and the Spanish-American War had all happened within his lifetime. He died at the end World War I. He had started life as a piece of property and ended his life as a respected and famous citizen of Batavia.

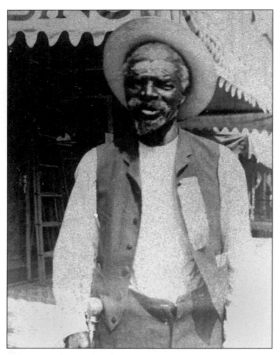

John Ozier's obituary gives us a small measure of what must have been a remarkable and resilient man. "Johnny was an original character. He possessed a bright mind and genial disposition. He drew many friend around him. Having lived here for 56 years, he was well and favorable known, being popular among the whites as well as the colored." And so he was. When he died on the 9th of June in 1919, at the age of 100, he was Batavia's oldest citizen.

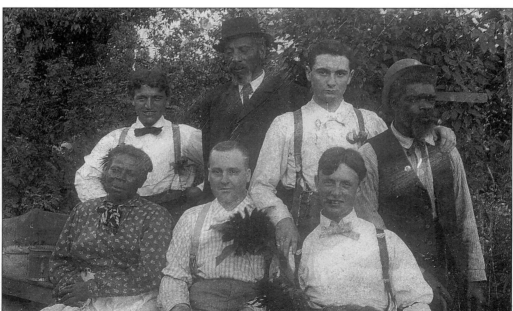

This last look at the early black community is of the Steven Smith family and friends. Smith is positioned at the peak of the triangle of people, with his wife in the lower left hand, and his son on the right edge. Their friends appear to be shop workers in town; notice the feather dusters. All the faces, black and white, tell us that these people related to each other and were friends. Notice the all-important hand on the shoulder of Smith's son. Not all towns in the U.S. at this time were as willing to break racial barriers.

Four
HIDDEN TREASURES

Once upon a time back in 1908, two young Batavia youths, Tracy Holbrook (see page 46) and Madge Grimes, took cameras and wandered the streets of their town photographing the people they encountered. They compiled these images into a scrapbook entitled *Batavia Celebrities, 1908–1909*. The title of their collection is a bit deceptive. Included in their album were the town's elite industrialists, doctors, and wealthy businessmen. But their lens also captured everyday people as well-shopkeepers, former slaves, mailmen, deputies, and laborers. Who could resist a young boy and girl on the street with a small camera asking if they could take your picture? Few probably did. These remarkable photographs stand today as one of the finest inclusive studies of a small town's people in the U.S., *c.* 1908–1909. They are a local, state, and national treasure.

Tracy and Madge lovingly placed 477 of their pictures into two albums. In 1979, copies were made from one of these albums (they both still exist) for their owners, William (Bill) Wood and the Batavia Historical Society. What appeared to be lost at this time were the negatives to all these pictures. Happily in 1980, the negatives were found! From these, high quality new prints were made. For the first time these "hidden treasures," many never before published, have come to light.

Another hidden Batavia treasure is the photo album of two remarkable Batavia couples, Fred and Elsie Krause and Frank Allen and Mabel Thompson. These pictures were taken as they toured the countryside in their open top car at the turn of the century. They took hundreds of pictures of things they saw in their travels and of themselves having fun. They even captured a fake race with a speeding steam locomotive. The real jewel in the collection is a series of comical studies of Fred with a barrel, which strongly resembles the style and best work of Buster Keaton.

Two hundred forty-six of the Holbrook/Grimes negative were in an Eastman-Kodak file folder. The remaining 203 negatives were stuffed inside a tobacco tin labeled "Bagdad Short Cut-Perfection of Blends for Pipe 'Smoking." After being lost for over 70 years, the collection of negatives matched almost perfectly the number of images in the album—only 30 were missing!

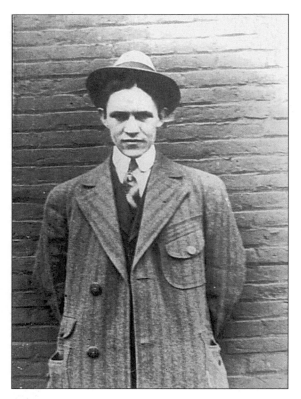

Tracy Holbrook is shown here as a young man. Over the years, Tracy and Madge kept up with the subjects of their photographic study carefully recording the death dates of the people in their album. The romantic story of the violin prodigy going on tour with his camera, returning home, and with Madge photographing the people of the town would make for a Hollywood blockbuster of a movie. The two never married.

Darius Bartholomew was born in Naperville in 1844, and was first married to Annie Lehman, then later married to Josephine McMaster. He had three children named Elmira, Arleigh, and Walton Henry. In1862, he enlisted in the 105 Regiment of Illinois Volunteer Infantry, which served in Tennessee. After the war, he farmed for a while in DuPage County before returning to Batavia in 1895. He died at the age of 72 in 1916.

Martin Micholson was born in Sweden in 1865. His wife Amanda bore him three children: Robert Manuel, Elsie, and Minnie. Micholson had three quite different jobs in his lifetime. At first, he worked for his brother, John Micholson, in his meat market. He was next employed by the Appleton Manufacturing Co. Finally in 1909, he worked as a mailman. He worked 20 years for the post office.

The gentleman to the left, knee deep in melons, is Frank P. Smith. He was born in Batavia in 1870, and was the son of Edward S. and Jane Mallory Smith. Smith and his wife, Jeanette, had one child, a girl, named Jeanne. His wife was a reporter for the *Beacon News*. Frank was a talented actor, but laundry was his real business. He founded the Mooseheart Laundry and was laundry supervisor for the State of Illinois. He lived to be 85 years old. The gentleman to his right is F. McGill.

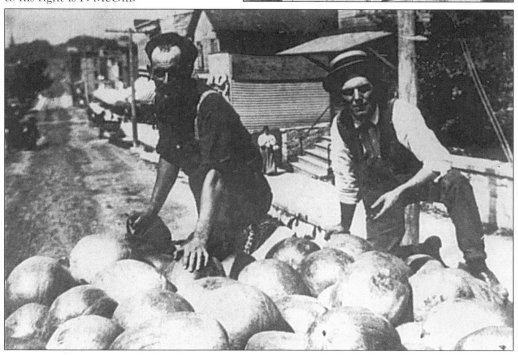

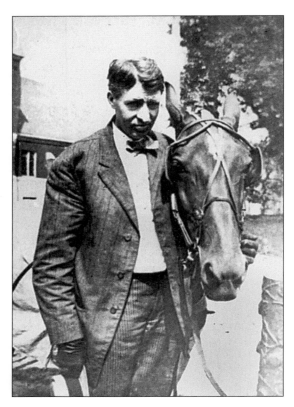

Doctor Charles B. Johnson was born in Batavia in 1867, east of town on the Johnson Farm. He married Cora Leach from Chicago, but had no children. Dr Johnson graduated from the east side schools, and received his medical license in 1892 from Rush Medical College in Chicago. For a time he worked with a large drug store in Chicago, but returned home for a year in 1893 to practice medicine. He then lived in Chicago for six years before returning to Batavia. Dr. Johnson practiced medicine in Batavia for 25 years. He lived on East Wilson Street.

John Geiss was born nearby in Aurora in 1863. His mother, Jane Jay, had been born in England in 1827. The family moved to Batavia in 1865, where he and his father, Jacob, started manufacturing cigars in a factory downtown. He was a man for all seasons. Geiss was a talented teacher of violin and other instruments. He was a leader of a cornet band, mayor of Batavia, twice postmaster, alderman, baseball team manager, bank president and director.

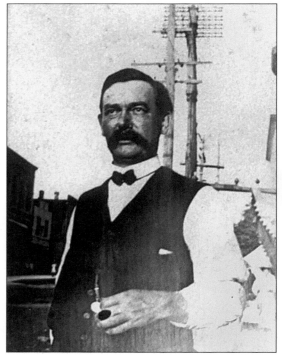

John Van Nortwick, son of William Mallory Van Nortwick, came to Batavia in 1846 to survey for the C&NW and the CB&Q railroads. He and his father established the Van Nortwick Paper Company. John was born in 1870, and in 1907 married Helen Buchwalter. The couple had two sons. John was born in 1910, and William Buchwalter in 1911. Batavia's old bank building is pictured in the background.

Nathaniel Rowcliffe was born in England in 1840, and received a tradesman education in shoemaking. He worked his craft in England until 1859, when he moved to Batavia. When war was declared, he enlisted in 1861, and fought with the 124th Regiment Illinois Volunteer Infantry. Rowcliffe was mustered out in August of 1865 and returned to Batavia to make shoes once again. He married Anna Perry of Batavia.

James Patch was yet another transplanted Englishman who came to live in Batavia. He was born in 1848 in Wedmore, Somershire, England. He and his wife, Sarah Ann Urch, and two daughters lived on South River Street. Patch and his partner, Lloyd Lemley, sold shoes and general groceries in a stone building on East Wilson Street. He was a member of the Baptist Church, and lived to the age of 77.

Franklin E. Marley was born in North Carolina in 1862, but received his education in Indiana, Iowa, and Nebraska. While in Iowa, he learned the printing trade. Marley studied medicine and law, but the newspaper business was his passion. In 1882, he started the *Kendall County News*. Marley then moved to Sandwich and published the *Sandwich Free Press* until 1892. That was the same year that he started the *Batavia Herald*. He was said to like the nicer things in life, such as fine horses and good dogs. Efie, his wife, had a school of oratory and music in their home.

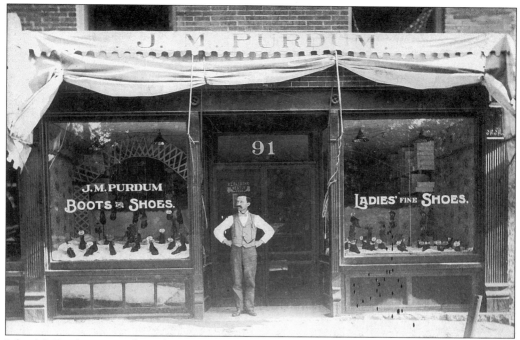

John M. Purdum started out his career as a farmer in Ohio. He came to Batavia in 1894, and the next year started a boot and shoe store. He invented a clever stool on which a clerk could sit while fitting shoes on the customer. Purdum was a Batavia alderman and a member of Calvary Episcopal Church. His wife, Ada, was a teacher in the Batavia schools. John died in 1938.

Benjamin Bradford was born in Yarmough, England, in the late 1840s and was brought to Batavia by his parents, Richard B. and Jane Teasdale Bradford. He and his father were farmers, and Benjamin also had other real estate interests. He started the first dairy in Batavia, which he ran for 28 years. His wife was Mary McMasters of Batavia, who was a member of the Woman's Columbian Club and served on the Batavia Board of Education. He died four years after this photograph was taken.

Immigrants came south from Canada to settle in the Fox Valley. Isaiah Griffin and his wife Mary Ann left their native Toronto and tried valley farming, but failed. They moved to Elburn in 1864 to run a hotel. After owning a hotel, Isaiah switched to the livery trade. Finally in 1885, Isaiah went into business operating a men's wear store with A.E. Davis. He had one child, a girl named Eden, born in 1868. He died in 1917.

John G. Mole was yet another talented English born man to find his way to Batavia. He came to the city in the 1850s to practice blacksmithing and inventing. He was a born tinker and for many years was employed by the Challenge Windmill Co. He filed patents on a corn planter, tire shrinker, an adjustable clamp, and a revolving trap for throwing glass targets. It was the tire-shrinker device which fitted metal tires to wooden wheels that caused him to build a small factory next to the Newton Wagon Works on the island.

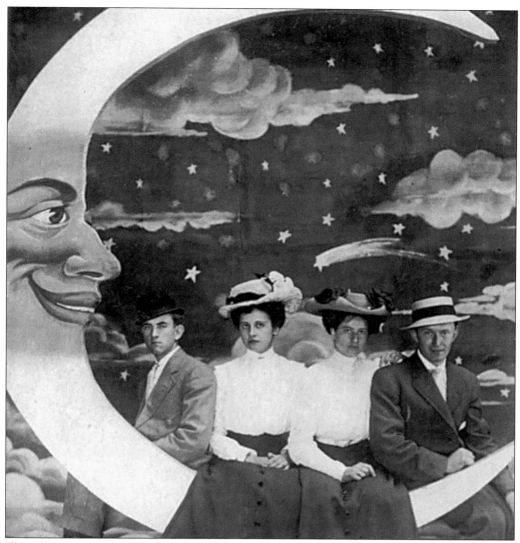

This photograph, taken sometime in the early 1900s at the famous Riverview Exposition by Foster & Coultry, beautifully captures the four young Batavians who roamed the countryside day and night in pursuit of a good time and a chance to take some pictures. The 2.5 by 4.25-inch pictures they took ran into the hundreds, and were all meticulously kept in an oversized, black-page scrap book by Miss Elsie Krause, one of the four adventurers. They are shown here cradled in the jolly old crescent moon. From left to right are Fred, Elsie, Mabel, and Frank.

The Krauses also developed their own film and made contact prints using Kodak and Ansco developing paper. Many of the extra prints not in the photo album were kept in the original contact paper folders, which were dated for use. For example, one folder is marked July 1, 1919, meaning that is when the paper was guaranteed to be usable.

The typical family photo album one finds in an antique shop or even in a museum's collection is often boring, featuring mug shots of dead people. Not so with this collection. The attention to detail and composition in each shot is quite remarkable. For once, a collection of images is so well done that you have the feeling that you know these long-ago people who are out to enjoy their youth.

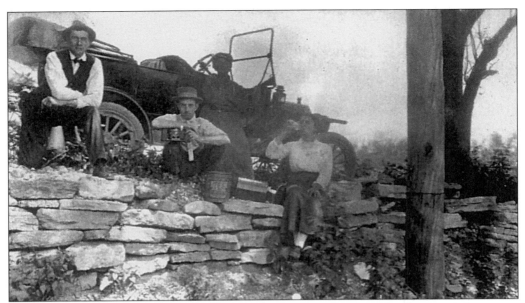

Ask the two Krauses to choose between their touring car and indoor plumbing, and the answer would have come back swiftly, "the car is a necessity." The two couples were constantly on the move photographing screaming babies, cows, windmills, parades, tornado sites, relatives, and lots and lots of train stations. All this touring was exhausting, and a picnic by the side of the road under the shade of the trees was a welcome relief from the dusty trail.

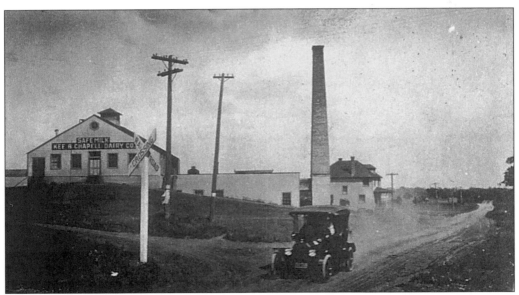

In the early days of touring, most of the major roadways paralleled railroad lines. In many cases, the area along the tracks had been staked out by local industry in order to ship their products to wider markets. All along the Fox River, various towns such as Elgin and Batavia had significant dairy businesses. Here we see our touring foursome passing near the railroad tracks serving the Kee & Chapell Milk Co., which states on its sign that it produces "safe milk." There were daily milk trains out of the valley to Chicago.

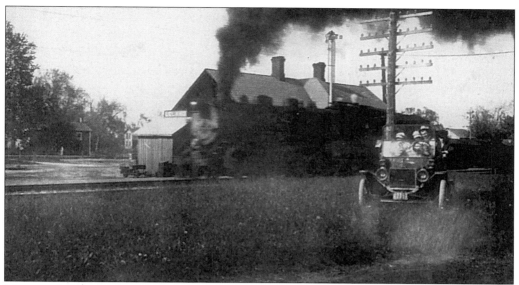

Most good photographs are the result of careful planning, yet appear to be spur-of-the-moment shots. Here our daring couples set out to simulate a race with a powerful steam locomotive by passing the Leland railroad station at a furious clip. They carefully positioned their car near the side of the tracks and waited for the scheduled trains to roar by to capture this exciting picture.

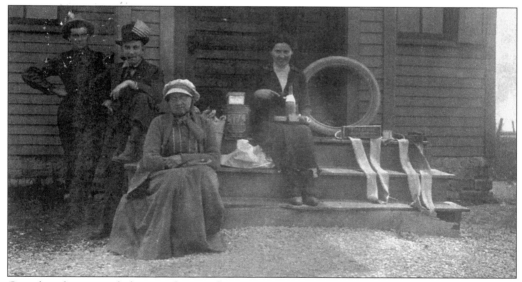

Grandmother joined the couples on this journey. One of the rules about taking pictures of people is to have them doing something rather than staring out at the photographer. Here, the subjects are not involved in any overt action, but the picture has interest because of what is telling us in a clever way. Facial expressions are varied, and the flag in the hat and the pointing hand describe a lunch stop and a tire change. Notice the Firestone inter tubes, box, and tire on the steps.

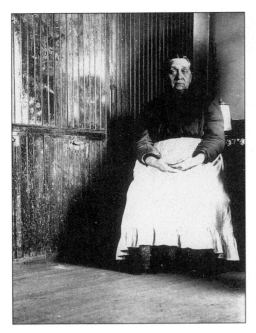

The grandmother is the subject of this riveting study. The side lighting which casts a shadow on the floor, the lines on the flooring leading up to the subject, and the vertical wood lines on the wall all contribute to the effectiveness of the photograph. The grandmother is not placed in the center of the photo but at the back of the picture for maximum attention. Folded hands on the lap help to convey the general feeling of sadness in this powerful character study.

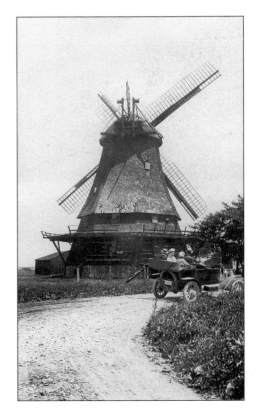

Our travelers are on the road again with its obligatory spare tire mounted on the back of the car. This time they are visiting Geneva with the huge Dutch-style windmill. This was quite different from the windmills produced in Batavia. It once used wind power to grind grain. This windmill was built by two German craftsmen and moved to Fabyan's estate in 1914. It took 19 months to reconstruct once there.

Fred Krause was acquainted with E. Weirich, who was a professional dancer specializing in body contortions as part of his act. Weirich was a mustached, slender man in 1909, when he was captured on film by Tracy Holbrook and included in his study of Batavia men. In order to prove that he could contort with the best, Fred Krause carefully staged a series of photographs of his "act." There is some indication that some of these were sold to the public as gag postcards.

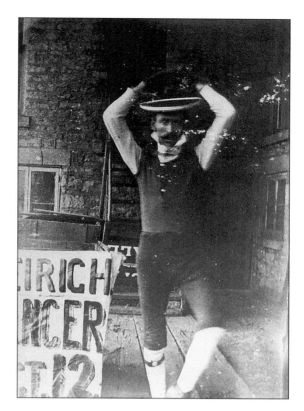

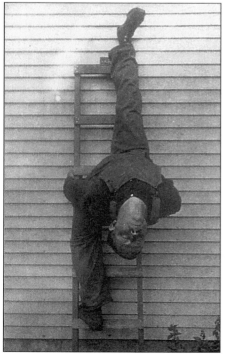

Fred's artistic blend of master photographer and contortionist pull it all together to create illusions that, even today, are breathtaking. Like all good "magicians," Krause has us guessing how in the world the person in the picture can accomplish this feat. Here he is walking up a ladder on the side of the house, defying gravity. Keep in mind that Krause had to have almost superhuman muscle strength to hold these poses while the slow camera lens could capture him without even a slight blur.

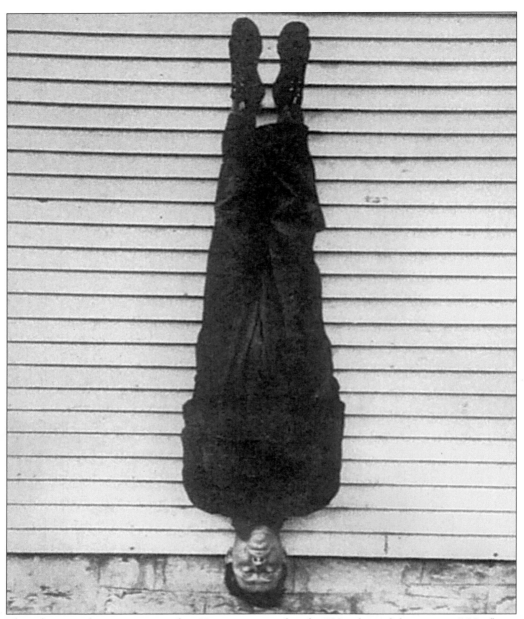

This photograph convinces us that Krause is every bit the "Houdini of the camera." He floats in the air, upside down, with apparent ease. Even if held for a short period of time, this position drains an abnormal amount of blood into the head. Using his ability to remain absolutely rigid, he used one simple device to pull off this illusion. Can you guess what that might be? The answer to the puzzle is in the index on page 128.

Fred Krause came from a large extended Batavia family. Most of the family lived at 190 Park, and a William F. Krause lived further out from town at 260 Park. Two members of the family, Herbert and William, worked for Kee and Chapell Dairy, and Katherine Krause was a dressmaker. Fred Krause worked at the Batavia City Plant, and William G. Krause was a blacksmith.

Fred Krause carefully set up his unusual photographs to show that one barrel and one man can entertain us with two perfunctory shots of himself. The first photograph shows Krause wearing a starched collar, tie, and two-piece suit. The suit is too small for him, and the light catches the fact that the suit could use a good pressing. He poses his body to give the illusion that he is wide-hipped and quite dumpy. Krause and all male members of his family were skilled blue collar workers, and this photo pokes fun at the physically "soft" Batavia white collar people in their "monkey suits."

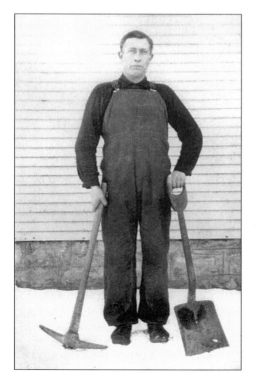

The plain backdrop of the side of a house provides an excellent backdrop for his feats, with horizontal lines to further emphasize the actions captured by the camera. Lighting can be controlled, and such a backdrop has the minimum of distraction. Here is the real Batavia man, a hardworking laborer with pick and shovel ready to move a mountain of coal, or hack away at a hill of Batavia limestone.

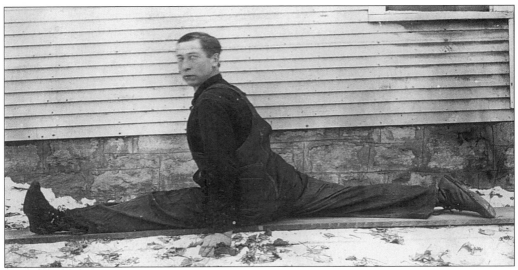

To let the viewer know that the clever images to follow were carried out by a man perfectly in control of his body, Fred does a split for us. "I can hold this all day if I want to," his eyes and body language tell us. Almost every vaudeville house had men and women who could turn themselves into pretzel-like shapes on the bill.

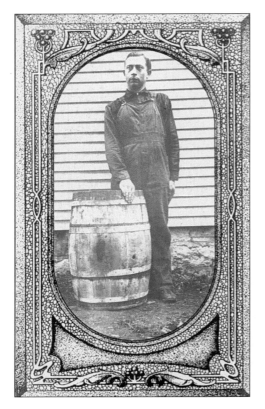

"And now ladies and gentlemen, I, Fred Krause, with the aid of an unknown photographer, will show you how I can take a common ordinary rain barrel to entertain and amaze you." The camera's lens is wide open in these pictures so that the wall, barrel, and Krause are all in sharp focus. The horizontal lines created by the wall boards made everything photographed in front of them almost three-dimensional.

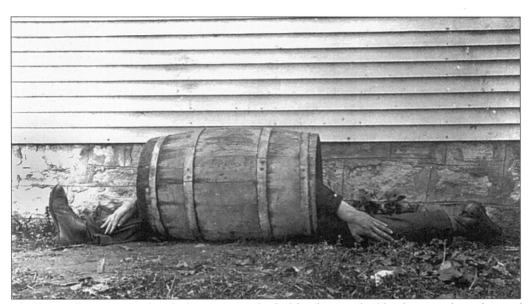

The fun really gets started with this image! It looks like this is a double photograph made up of two pictures. But remember Krause's previous picture and his effortless split. He somehow had gotten into the barrel with a bent chest, head down, and with his arms projecting out of the two ends of the barrel. Notice that all the composition lines in the photograph are horizontal.

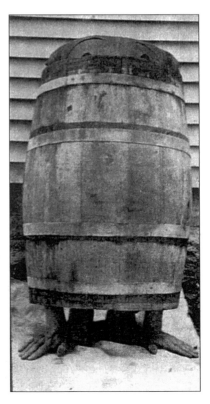

Had Krause been willing to travel, he could have joined up with a circus as a "Rubber Man." Krause's body control and ability to inject humor into his act would have provided relief from the tragic "freaks" put on display. He could have challenged customers to duplicate his tricks for prize money. Notice how the photo cleverly puts his feet in shadows, while his hands appear to be holding up the barrel.

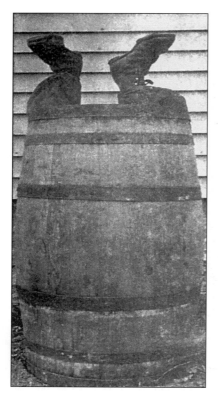

If a picture of Fred walking around on his hands wearing a barrel is funny, then a shot of him stuffed into the barrel with only his feet showing would be a good laugh as well. If this photograph was ever sold to the public, women surely stood in line to buy copies. Many women in this period before World War I, forced to live in a mostly male-dominated society, probably would have liked to do this to their husbands, boyfriends, and fathers at one time or another.

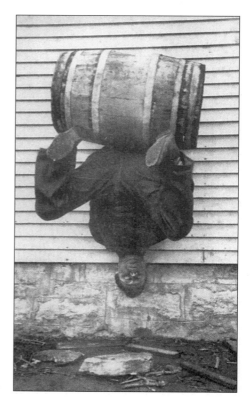

If you have figured out how Fred was able to float upside down without any visible means of support in the previous photograph, you know how this picture was done. Once again, it is a marvel to see the work of such a fine illusionist as Fred Krause, who surely should be called one of Batavia's greatest artistic unsung heroes. He was a master of body and camera as well.

We now come to the grand finale of this set of images of a man and a barrel. Once again the lighting is carefully controlled. You see only the booted feet in the dark part of the barrel. The barrel, for all intents, looks like a turned over trash barrel with an old pair of boots sticking out to the unobservant viewer. When Fred was not practicing his magic with a barrel, or buzzing around the countryside with friends and family, he was bicycling or riding his favorite new motorcycle.

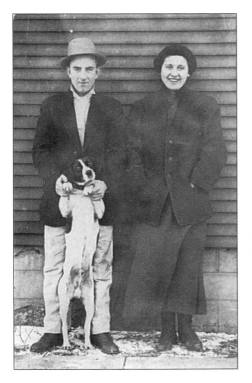

Almost all of the photographs taken of the Krause and Thompson family are upbeat and celebrate the glory of life. These friends seemed to relish and thrive on the humor of the human condition. In today's vernacular, they would embrace the terms "lighten up" and "be happy." The dog is cooperating and holding still, his paws held by the man, and Elsie Krause is giving us another of her infectious smiles. Elsie Krause was married to a Sloggett and this, in all likelihood, is her husband.

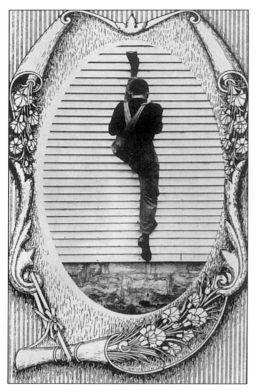

This is positively your last chance to guess how Fred Krause was able to magically invert himself in the air, walk on a ladder totally on a wall, and walk up the wall with a barrel. Here he is "walking the wall ." He is not being held up by his feet. This photograph is on a beautifully decorated postcard and is as sharp as a glass slide photograph.

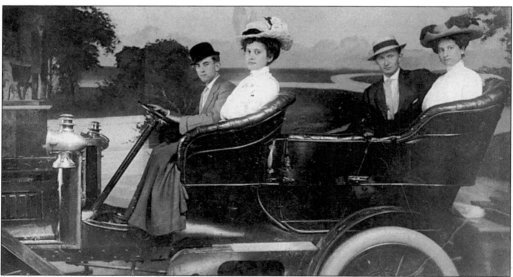

A fitting end to our ramble through the Krause (Sloggett) family photo album is to take a look at the "old gang" photographed at Riverside Exposition Park in an old touring car reminiscent of all those journeys in their own motor car throughout the lands around Batavia. The photographer's backdrop is in perfect harmony with reality, for it features a winding river. Neither of the girls would have dared to go touring with such fancy hats without large shawls to hold the hats in the breeze.

Five
Bicycles, Banjos, and Ball Parks

By the 1890s, United States industrialism was beginning to surpass former leaders in the field, such as England and France. At last, our country was exporting more goods than we brought into the country. New and more modern American factories, using unskilled workers from all over the world coupled with state-of-the-art machinery, began to produce thousands of lower priced goods. Workers in the factories were taught to become more and more efficient, and while salaries throughout the decade did not increase, the prices of many products dropped, drastically making their dollar worth more in the marketplace.

Workers in Batavia and across the land suddenly found that they were no longer required to work a seven or even a six day week. After being carefully taught by churches, schools, and their bosses not to waste time, they now had time to waste. Inventors and manufacturers began to crank out the machinery for huge amusement parks.

Americans now had to learn how to have fun. From baseball to bicycles, the need to have fun became the latest craze. Thus the leisure time industry in America was born. Batavians began to make plans to fill their after-work hours. Adults began to create their own toys, such as the bicycle. Home-grown advertising in Batavia was sharp and way ahead of its time. One creative merchant in 1899, J.M. Purdum, who owned a shoe store in Batavia, showed a big watermelon in his exhibit at the Kane County Fair, and offered a free pair of shoes to the person who came closest to guessing the number of seeds in the melon.

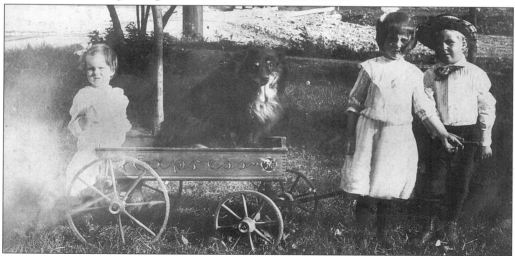

Cats, dogs, and small dolls were favorite toys in Batavia. Here in 1900 is Louie Parre with his collie dog "Babe," with Viola McDowell and friend. These children have a "store-bought" wagon. Although wagons such as this only cost a few dollars, many children had to make their own wagons and carts from wooden apple crates and cast-off round flywheel castings from local foundries.

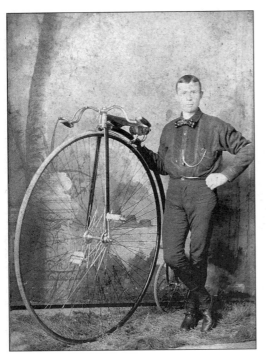

The bicycle became the first popular personal transport to replace the traditional mode—a horse. The first bikes appeared in this country at the time of the 1876 centennial celebration, but did not really catch on until the mass production assembly line was used in factories to produce the "safety." Before the safety, which had two wheels of the same size, high riders ruled the road with their curved backbone frame. Brakes were nonexistent on these beauties. Batavia master photographer, G. Wellin, has captured a proud local cyclist, Johannes Benson, in his studio with simulated grass and outdoor backdrop.

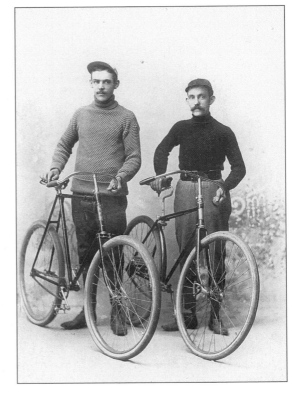

This pair of Batavia bicyclists are set to hit the open road with their new-style, chain-driven safeties. These new bikes were easier to mount and came in models for both men and women. Bicycle factories developed trade names for bikes such as Columbia, Imperial, Sterling, Packard, and Ford. Some sewing machine factories were converted to making bikes to meet customer demand. By 1907, bikes could be bought for about $25 and were equipped with coaster brakes. For a time, tricycles were popular with men and women as bicycles built for two.

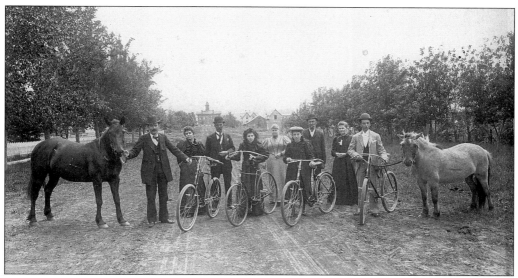

Bikes for women had lower curved cross supports, and were equipped with the latest invention of the day, a hygienic saddle with soft strapping in the center. Doctors endorsed riding as exercise, and bicycle clubs sprang up all across the valley. In order to sell their brand of bike over other brands, manufacturers developed some of the first ad slogans: "built like a watch," "a study in vibration," and "like a trusted steed." Here in this remarkable image, the old (horse) comes face to face with the new (bicycle).

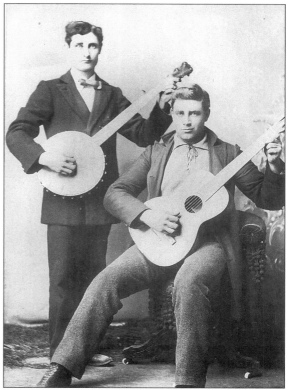

Cheaper than $60 reed organs and $200 pianos, guitars, and banjos could be purchased in general stores in Batavia or from Sears, Roebuck and Co. for as little as $2 in 1907. Batavia was famous for its love of music. It had many talented amateur and professional musicians, and was noted for its orchestra and various string and brass bands. Walter Stone is the serious looking banjo player on the left. He was born in 1875, and lived until 1964 on Washington Avenue. The seated guitarist is Quincy Parre with the six string banjo in this 1892 photo.

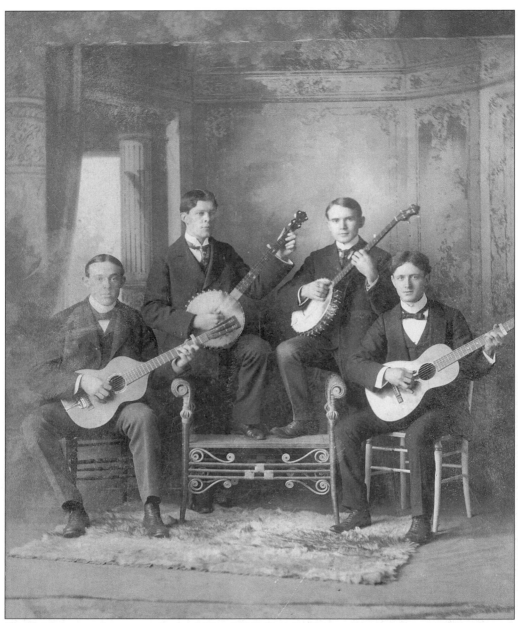

So what's better than a string duo? The 1890s Batavia String Quartet shown in this elegant photographer's studio set, that's what. First on the left is John Van Burton, a future Batavia mayor. Next in line is Harry Belding, who founded a construction company in town. Frank P. Smith is the second banjo player and a future founder of Mooseheart Laundry. He was a talented actor and musician. To his right is Guy Conde, who worked in the family candy store on the island.

There was even an opera house in Batavia for the group to perform in. The music hall was on South Island Avenue. It differed from many other opera houses of the day in that it was located on the first floor of the building. By 1917, the hall was used as a movie house.

The many diverse immigrant groups who came to Batavia from Europe and the British Isles brought with them their folk music and the violin and accordion, which were true instruments of the people. Put a skilled violinist and an accordion player together, and you had the makings of almost a whole orchestra of sounds perfect for dancing and entertainment in local parks. The violinist is Ernest Gabrielson, a Batavia carpenter and home builder. The player of the squeeze box with three stops and three sets of reeds and two bases is unknown.

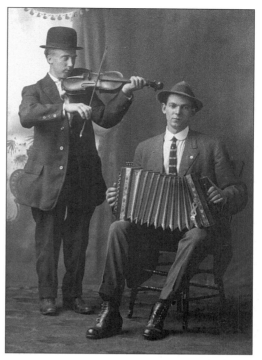

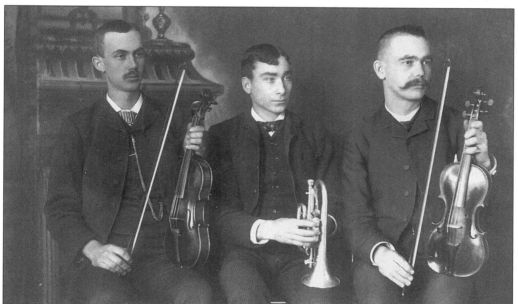

Sitting between William Kay on the left and an unknown violinist on the right is one of Batavia's most unusually talented men, John Geiss. He had a cornet band in town and also helped run his father's cigar manufacturing business for 50 years. He taught all types of instruments and served as a Batavia mayor twice. Somehow he also found time to manage some of the city's best baseball teams, was president of the local Building and Loan, and was a director of the First National Bank.

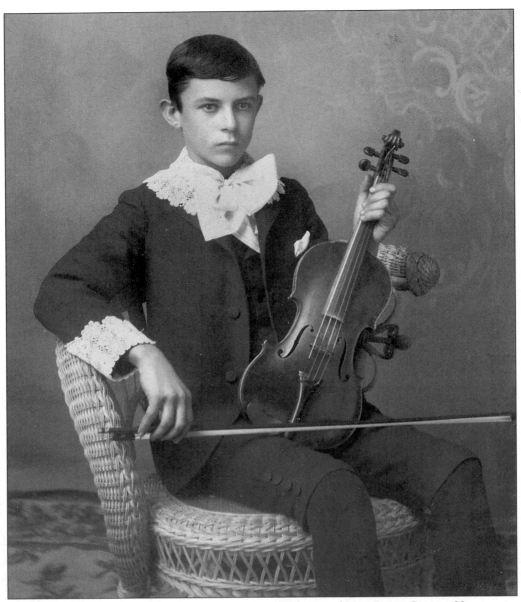

Tracy Holbrook lived on the southwest corner of Wilson and Van Buren Streets. He was one of three sons born to Emmanuel and Emma Holbrook. Tracy's father was a Batavia hardware dealer and his mother a music teacher. At the age of three, Tracy, "the musical wonder," appeared for the first time in concert at the old Batavia Music Hall, not playing the violin but a harmonica. When Tracy was five, he was reported to be able to mimic complicated pieces played for him on a violin. Later he toured with a group of musicians who, it is said, played in every old soldiers' home and penitentiary in the United States. President Theodore Roosevelt issued an invitation for Tracy to play in the White House at a special gala concert in 1903. Six hundred guests were thrilled to hear his playing. The next day he gave a private concert to Mrs. John A. Logan, wife of the famous Civil War general. Holbrook left Batavia around 1914 to become the conductor of the Star Theatre orchestra in Hannibal, Missouri.

While making and listening to music filled many hours of leisure time for Batavians, they also enjoyed weekend picnics in the city's own big-time amusement complex, Laurelwood Park. The C&NW Railroad wanted to utilize its parked locomotive passenger trains on Sunday by taking recreation-starved Chicagoans to a day in the country. The railroad built a 2.2-mile extension from the mainline in Geneva down the east side of the Fox to a 30-acre wooded site on River and Logan in 1893. By 1897, the railroad was running eight train loads of visitors each summer Sunday, and for the popular annual Swedish Mid-Summer Festival in 1899, 20,000 people packed the park.

Grand Pic-Nic & Concert
.....GIVEN BY THE.....

ELGIN BAND,
SATURDAY AFTERNOON and EVENING

September 18. 1897.
......AT......

LAURELWOOD PARK, BATAVIA !
BALL GAME! BALL GAME!
At 3 o'clock, between the Elgin Kings and Batavians.
(A HOT ONE.)

Balloon Ascension at 5:30 p. m. Dancing until 11:30 p. m.

BAND CONCERT From 8 till 9:30.

Will sell Badges for admission to Park. Gents 15 cents and Ladies 10 cents. Return check will be given at the gate for evening Dance and Concert.
DANCING ALL DAY.

Special Car to Aurora at 11:30.

The Chicago, Aurora, and Elgin Electric Line had built a rival park called Glenwood Park in 1900 at their stop in Batavia. The park had many of the same attractions as Laurelwood—a park, a giant merry-go-round, a dining hall, swings, tables, and a covered pavilion. A steam launch took park visitors for a journey on the Fox River.

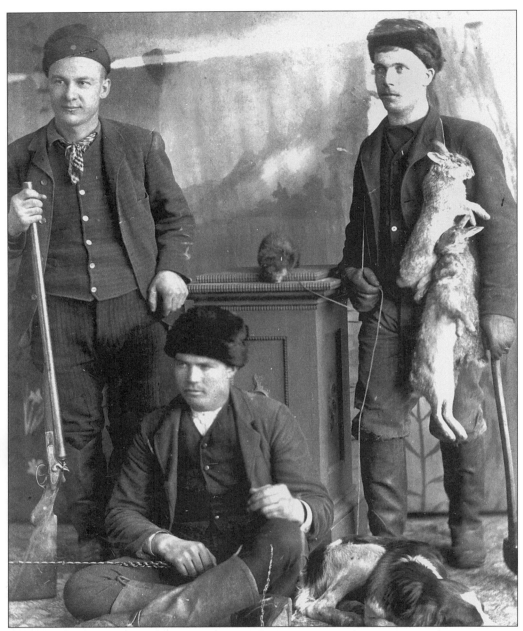

Another popular pastime, which in pioneer days was not so much a fun activity but a necessary one for survival, was the manly art of hunting. One of the first American manufacturers to mass produce guns with interchangeable parts operated in the early 1800s. Before whites settled in the area eventually to be called Batavia, the land along the Fox River was wooded and heavily populated with wild game, birds, and animals. The Batavia hunter on the left proudly displays his double-barreled shotgun with hammer breach loading. Such guns, depending on the quality, were available at this time for as little as $8 to $12. The hunter on the right displays three rabbits and a ferret on the stand. Seated on the floor with his trusty dog is Jim Hamilton, who worked in the heating plant at Mooseheart and was a home renovator.

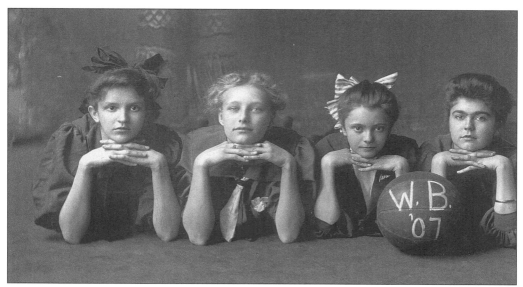

Public and private schools rushed to add sports to their curriculum. Any sport involving a ball became the darling activity on campus. Women and young girls began to emerge from their Victorian bondage in many ways at the turn of the century. They were slowly being permitted by society to engage in physically strenuous sports in the schools. This annual photograph shows four young ladies who were on the West Batavia team in 1907. This was a typical shot in countless annuals where the photographer emphasizes the girls' cuteness rather than their athletic zeal.

The 1909 West Batavia High School football team looks proud and virile in this photograph taken after a win over West Aurora. Pictured, from left to right, are as follows: (front) Frederick "Tubby" Burk, quarterback; and Ray "Irish" McDermott, end; (middle) David "Little Dave" Anderson, guard; Parks "Duck" Bailey, fullback; and Raymond "Henny" Henderson, guard; (top) Clarence "Cal" Swanson, right half-back; and P. "Vic" Thelander, left half-back. Other team members were not present for the photograph.

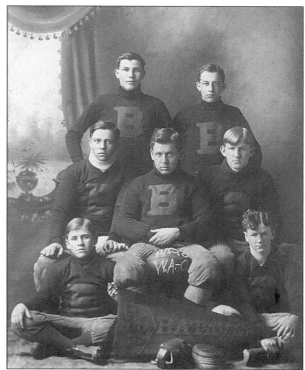

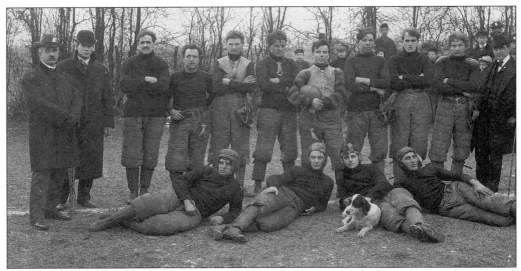

By the end of the 1890s, secondary schools and universities alike were caught up in sports mania. Football was a brutal game in those days. Win at any cost was the watchword of the day, and there were frequent sluggings and free-for-all fights. Notice the hockey-like leg protectors and lace-work leather helmets on this rough-and-ready Batavia football team.

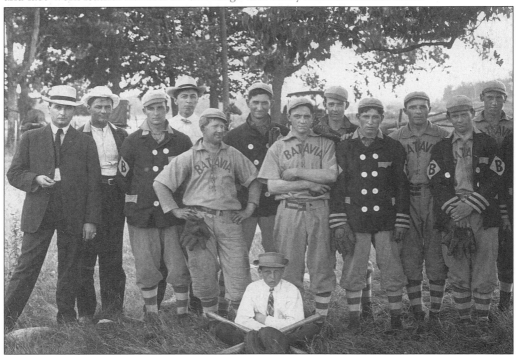

The Batavia Blues baseball team of 1897 had named Edward Hutter to be their mascot. The team came from all over the Fox Valley, Chicago, and even from as far away as Michigan. Batavians who were associated with the team were R.C. Hollister, A.T. Rogers, Frank Renaud, Frank W. Hopkins, Thomas (Tom) Kelleher, Thomas (Tomy) Snow, Arthur J.J. Barekley, and John H. Sanders. The Blues, with their impressive coats, were still competing in the 1930s.

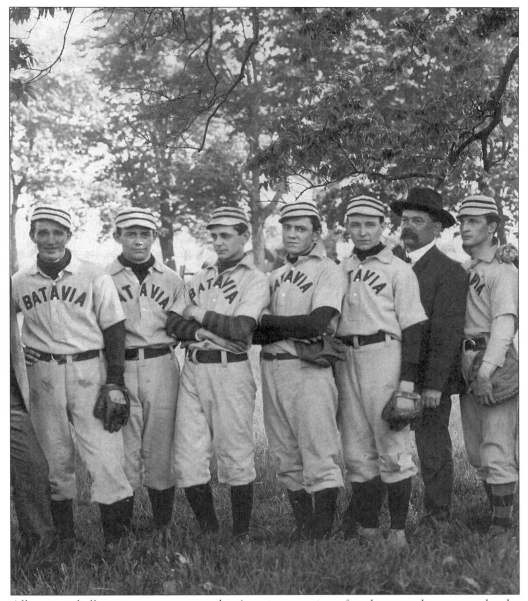

All contact ball sports were very popular American pastimes for players and spectators by the turn of the century, but it was the game of baseball that won America's heart. The British had an earlier version of the game called rounders, but it was not quite like the American game. Local businesses sponsored teams as did big city, newly-formed, athletic clubs. Baseball was king, and still is for many Americans. In a 1888–89 tour, the Chicago White Sox even played in England before the Prince of Wales.

This picture includes part of the Batavia team that was the champion baseball team of northern Illinois in 1906. Note the entirely different look of the uniforms compared to the 1897 Batavia Blues garb.

Standing, from left to right, are: M. Sullivan, T. Snow, L. Ornachre, W. Modvil, J Crone, J. Geiss, and F. Hopkins.

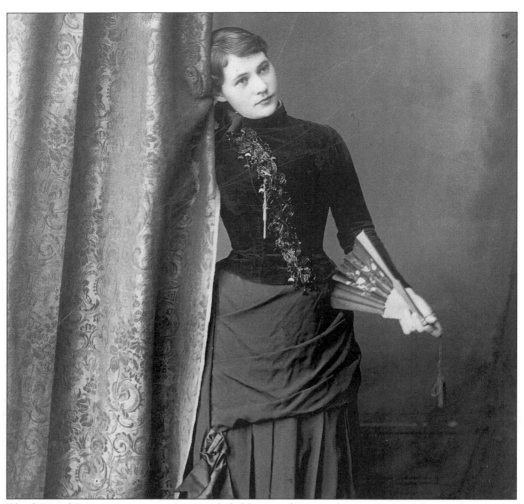

The lives of Batavia's men, women, and children underwent drastic changes during the waning days of the Victorian Era. There was more leisure time for almost everyone regardless of their social class, and a record number of immigrants not only melted into the fabric of America but also prospered. The lives of men and women, once controlled by a rigid set of rules of what each could do, were beginning to change. World War I skyrocketed women into new jobs and positions of responsibility, and the rising popularity of sports would slowly break down sex and race barriers later in the century.

In this classic image of a Batavia beauty with her elegant dress and fan, G. Wellin has captured the very essence of a young lady's poise and beauty. She appears to be a woman who is a million miles away from an interest in remaking the social rules and barriers, content to be only an object of romantic love and appreciation.

These words of Charlotte Becker, late Victorian poet, seem a perfect companion to this picture.

> *"You were the first—you taught my heart the song*
> *Of olden wonder, and my pulse the long,*
> *Sweet thrill of rapture; showed me paths of dream,*
> *And laid across life's dark a silver gleam—*
> *You were the first."*

76

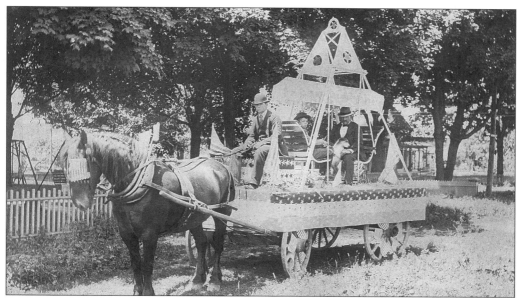

Batavia, like many other communities in the Fox Valley, had a diversity of people. Public holidays such as the Fourth of July were a great opportunity for all the folks in town—Irish, German, English, or Swedish—to come together and rally around the flag. All this provided great entertainment, a chance to take the day off and meet old friends, and hear new gossip. In this photo, three men are preparing to take the float they have built into town for a parade. It was to feature the women of the Eastern Star.

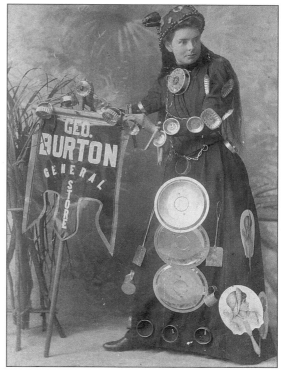

The big Batavia affair in 1892 was a competition held downtown among the merchants. They decorated pretty, young girls with items which could be purchased in the stores. This young lady represented George Burton's Grocery Store. The store was a general store also. Hand-held fans, tin cups, fly swatters, and cookie cutters all provide colorful additions to the dress of this long-haired beauty. The banner suggests that a parade took place on this special Merchants Day.

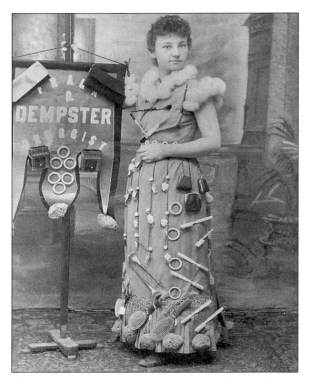

Another entrant in the big to-do in downtown Batavia was merchant D. Dempster, who ran a drugstore. The attractive young lady in this merchandise/beauty pageant was 16-year-old Mary Kenyon. All these young ladies were sent into the studios of photographers for these pictures. Hair and paint bushes, watches, cutlery, and sponges decorate her now-heavy dress.

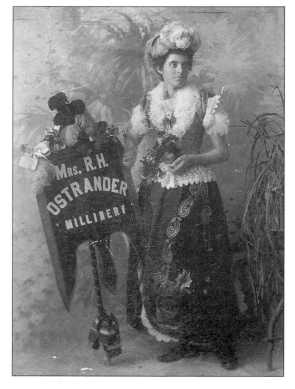

Our last entry in the contest was Mrs. R.H. Ostrander, who handled millinery. The beauty modeling the latest chapeau and extremely ornate blouse and bodice is Irene Wood. With all this feathery look topside, she resembles the white swan in the ballet *Swan Lake*.

Six

INTERIORS OF OLD BATAVIA

Ask conservators of old photographs what they would like to see more of in their collection and the answer would be interiors—interiors of homes, public and private buildings, factories, and businesses. There are thousands of photographs of factory workers arranged in rows outside the factory wall for every one showing the man at work inside. In order for an image to be recorded on glass, paper, or metal, early photography needed a lot of light. Most factories had only patches of light streaming onto the floor. Watch factories, on the other hand, had quality natural and artificial light, because their workers were doing minuscule, precise assembly work.

Also, photographs of the interiors of old homes are hard to come by for several reasons. First, who would have thought photographs of home interior would be of interest in the future. How many of you photographed the rooms of all the houses you have lived in, except for insurance purposes? Secondly, lighting glare from windows and poor portable flood units for photographers made interior home shots all but impossible. Only in studio photography studios, where the studio could be made up to look like a living room, could the photographer make good pictures of interiors. Here furniture was usually used only as a prop. The Batavia Historical Society is fortunate to have an excellent set of interior photographs of Mrs. Selfridge's home. These are rare glimpses of the rooms in her house on Batavia Avenue.

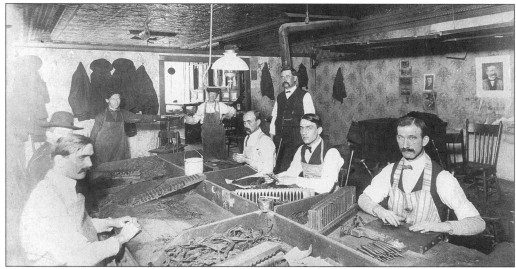

Cigar making is very labor intensive, and even today requires few tools. These employees of the Geiss Cigar Factory are seated at the cigar-rolling table. Madge Grimes wrote that Otto Konrad made all the cigars sold by Geiss in the 1890s. The Geiss Five-Cent Cigar was widely known. At one time a famous American politician noted that all the country needed for prosperity was a good five-cent cigar.

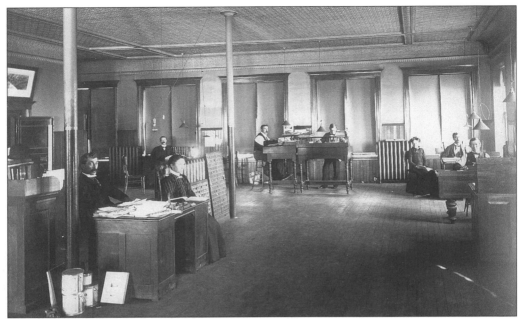

This office of the Challenge Company was fairly typical of the day in that desks were lined up near the windows. Notice that there are only a couple of ceiling lighting fixtures. The men at the tall desks were working on the accounts of the business.

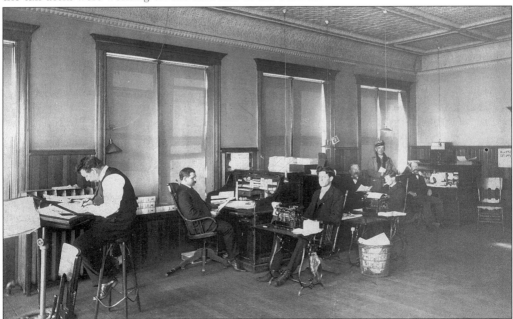

This may have been one of the sales offices for the Challenge Company. When telephones were new, there usually was only one in a room of up to 30 people. It was reported that when the Challenge phone rang, one of the office workers ran to answer it. If it was for the president, a messenger ran back across the room to the president's private office to inform him. The president then sauntered off across the room to answer it.

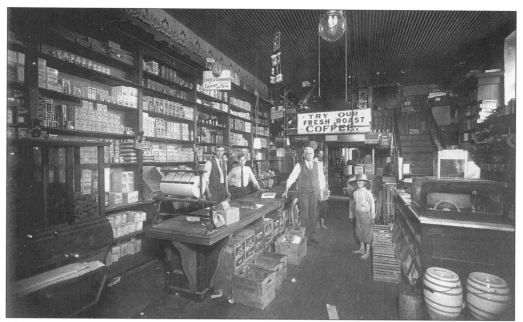

This photo of a typical grocery store interior was taken around 1911. The proprietor may have lived upstairs. The boy could have been a delivery boy or a youngster looking for penny candy. By 1926, orders were usually placed by telephone, and six deliveries were made to the customers each day. Most town folk charged their purchases rather than paying cash.

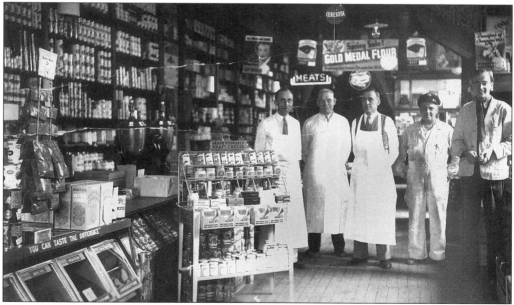

Ed Zuehl, August Swanson, Herman Schielke, unknown, and Donald Schielke posed for this photograph in the Schielke store in the spring of 1938. Note the prominent display of seeds and the individual portions clipped to a rack above the coffees. The barrels and boxes of produce are no longer visible but are behind the counter for inventory control. The days of free crackers for the visitors were over.

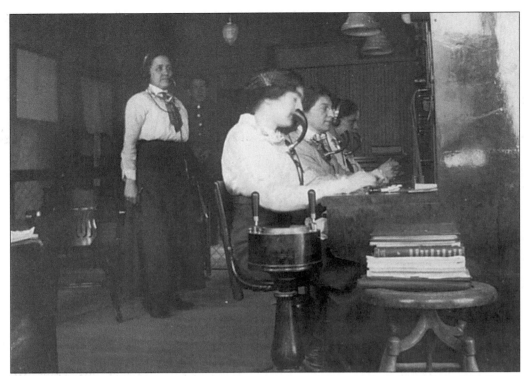

Batavia's telephone exchange was located on the second floor of the Meredith and Holbrook Block on Wilson Street. Viola Laker and Ed Scheid are the supervising operators here; Alice McBreen, Bertha Ducket and Hazel Sova (from back to front) answered the calls that came in.

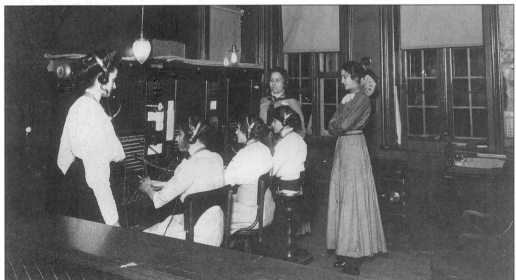

Much later, chief operator Anna Koehler oversees the operators in 1911. Notice the improvement in mouthpieces, but not in much else, for the operators. Many early exchange operators memorized names and numbers and could connect you if you gave only the name of the party to whom you wished to speak.

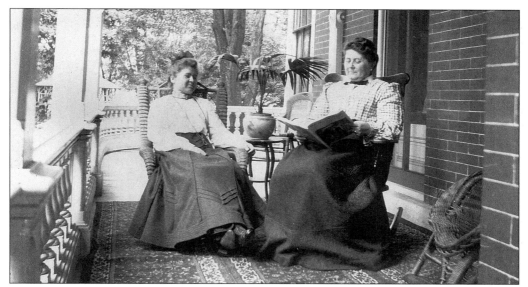

"Mother Newton and Nellie" is the caption under this porch scene from the album of Mrs. Mary E. Newton and Nellie Newton Selfridge. Nellie married William Selfridge in 1901, and this house reflects the newlyweds' first furnishings. The porch is being used as an outdoor summer sitting room, complete with a fancy carpet. Mrs. Selfridge's house on North Batavia Avenue was very elegant.

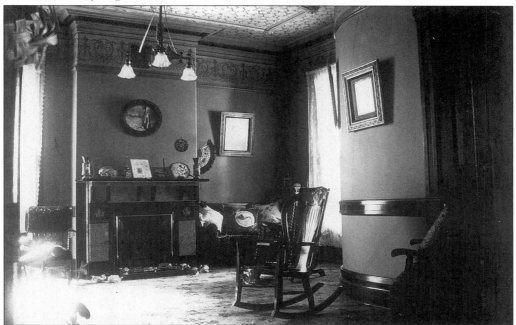

The next few views of Mrs. Selfridge's parlor and sitting room are taken as the photographer focuses to her left, center, and right around the room. You may notice that chairs are moved from space to space as they are needed. This random placement was typical of a much earlier time than that of the photographs. The electric lights, radiators, and oversized sheet music in a later photo date this series of photos to the early 1900s.

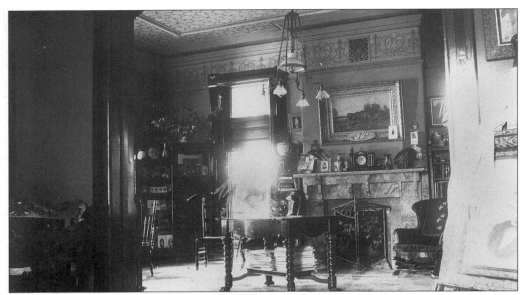

Pocket doors often separated a parlor from the sitting room. This view is looking into the sitting room from the parlor. The sitting room was for the family's more intimate use. The parlor was a place for receiving guests and holding weddings and wakes. After the Victorian period, some ornamentation continued to be used on the ceiling and in rug designs. These rooms also have a wide, decorative border around the walls near the ceiling.

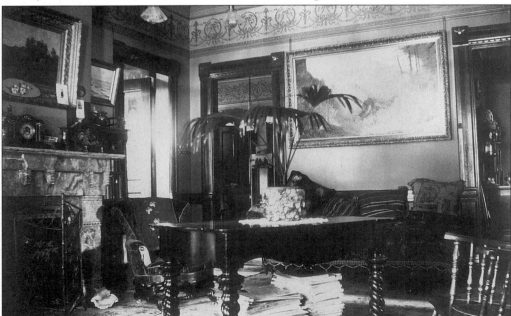

The tea table is positioned in front of the fireplace. Newspapers and magazines are stacked on the under shelf. When in use, chairs are pulled up to the tea table. The only lighting fixtures shown are in the ceiling, over the tea table, and over the piano. Light for reading must have come from daylight streaming through the windows or kerosene lamps later in the evening. Most houses of this period were dimly lit by modern standards, even with electric light.

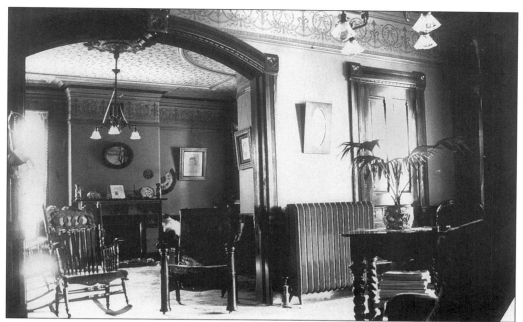

This view is of the parlor taken from the sitting room. Notice that the rocking chair has been moved away from the tea table. Rocking chairs are said to be America's greatest innovation in furniture. They were often regarded as the best chair in the house, and it was considered a favor to be given a rocking chair to sit in.

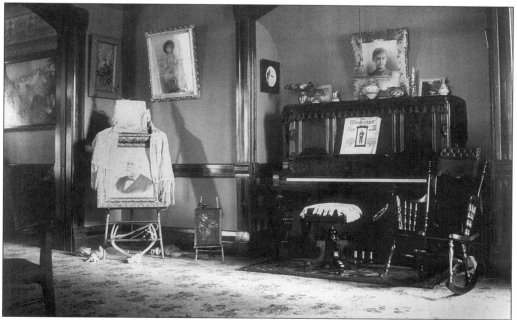

The last photo of the parlor shows that the piano was given a position of honor in its own niche with a light to help the player see the music. Also grouped in this area are portraits and ornaments of value. The shawl over the man's portrait and the items around it suggest a memorial, a throwback to Victorian interiors.

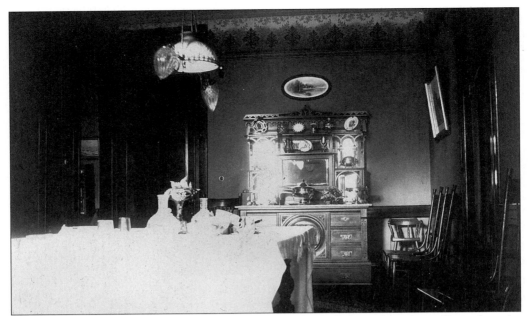

The dining room features a partially set table. A variety of chairs line the wall, ready to be pulled up at meal time. The china and tableware were probably stored in the sideboard, since there seems to be no butler's pantry between the dining room and kitchen. The table may not be permanently placed as indicated by the height of the lighting fixtures above it. In fact, there may be more than one table in the room. Notice that the table cloth is much longer than the table it covers.

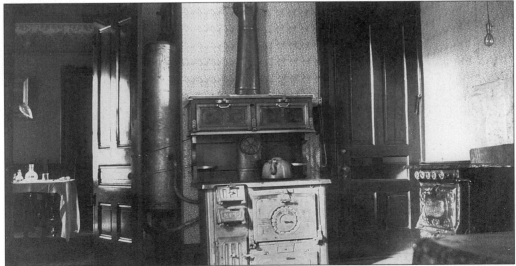

This hot-water front range is of a type that was featured in the 1908 Sears, Roebuck catalogue. The tank on the left of the stove stored heated water coming from a coil placed in the firebox. Coal or wood could be burned in this stove. You can see the dining room through the door to the left. Another door to the right seems to have the horizontal panel cut away. Notice the absence of cabinets to store dishes or food products. These were not part of a standard kitchen at this time. The kitchen was strictly for food preparation, not used as a pantry or root cellar.

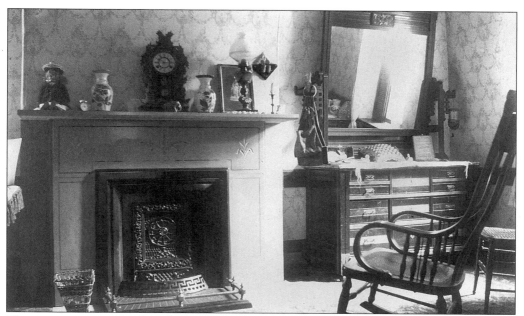

These two pictures are of Mother Newton's bedroom upstairs. The steam heat must have been only on the first floor, since this fireplace has been fitted for a coal burning, Franklin-style stove to keep the room warm. There are at least two rocking chairs and a straight chair in this room for Mrs. Newton's comfort. You don't find many upholstered pieces of furniture in this house.

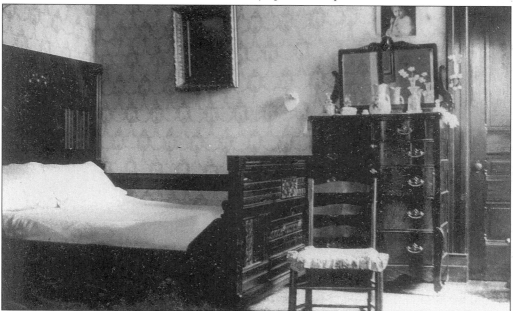

The massive bedstead dominates this portion of the room. There are mirrors over both chests of drawers and dresser scarves protecting the tops of each. This room has a much more Victorian feeling to it than the downstairs rooms, probably because the upstairs rooms were usually furnished with pieces no longer considered fashionable or good enough to be in the public rooms.

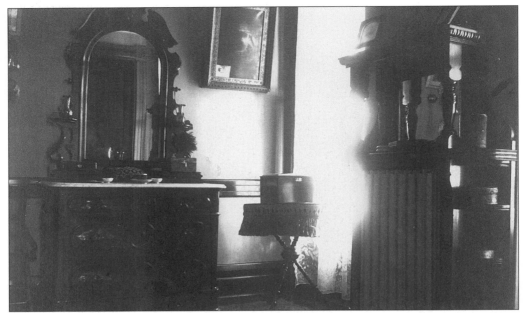

The steam heating system is again in evidence in this downstairs bedroom. Very often a downstairs bedroom was used for sick or convalescing household members. Large homes of this period usually housed several generations of the family. Elderly members of the household also used the downstairs bedroom when they could no longer walk upstairs. Although the furniture is grander, there is much less clutter shown here.

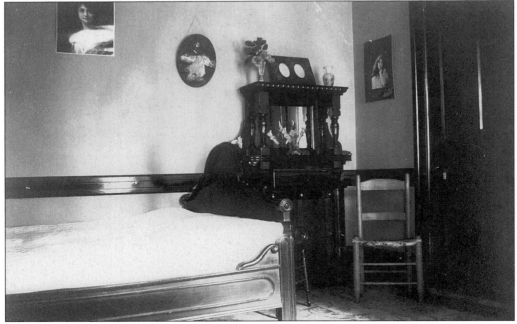

The bed in this downstairs bedroom is narrower than the beds upstairs but the frame seems to be just as massive. No rocking chairs are seen here, but plenty of drawer space is available. Family portraits are hung at random.

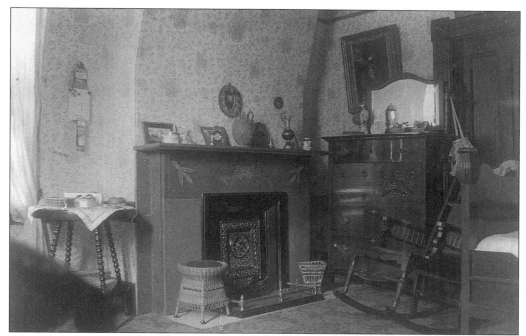

These two photographs are labeled "Nellie." They may have been some sort of upstairs sitting room. Nellie's room retained the wallpaper, and also had a cast-iron stove to warm the room as well as a comfortable rocking chair. One of the few side tables photographed is placed haphazardly in the corner of this room.

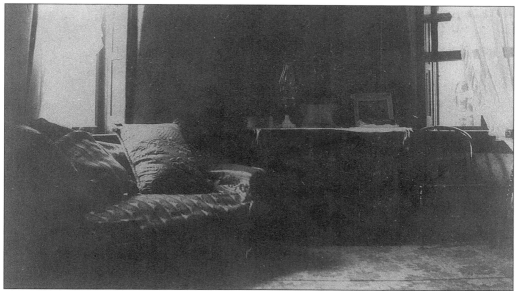

In houses of this time, rooms were small by today's standards. There generally was one bathroom for the whole house, and it was upstairs. This house had interior folding casement shutters to help keep the cold out. You can see that a drapery was hung over a large mirror so that the camera would not appear in the view. The chest has a kerosene lamp standing on it, which was used to supplement the single bulb in the center of the ceiling.

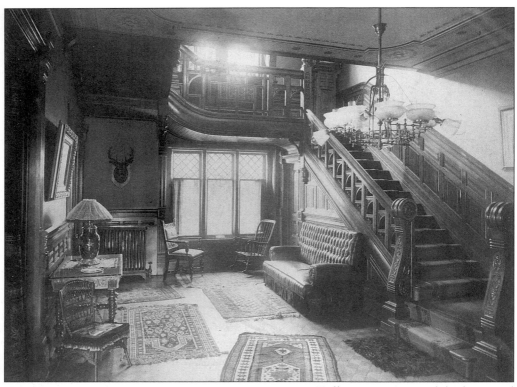

William Van Nortwick built a grand house on the northeast corner of Batavia Avenue and First Street. It was both larger and more grandly furnished than the Selfridge house. The light fixture was originally fitted for gas but later was refitted for electricity. Even this grand house had a rocking chair in the main hall.

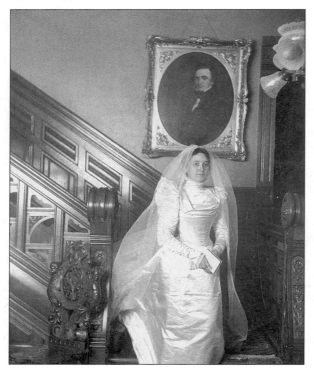

Louise Van Nortwick was the granddaughter of the first Batavia William, and daughter of William Mallory Van Nortwick. She is posed here for her wedding photograph in 1897. Grandfather William's portrait is hanging above her, replacing the hunt scene in the above photo. Louise married Guy Despard Goff, who was a senator from West Virginia.

Seven

PLACES OF QUIET AND MRS. LINCOLN

Today certainly places of quiet are important safe havens for frantic times just as they were in a distant past. The havens featured here that soothed, educated, healed, and provided spiritual direction were old Batavia's rest homes, churches, libraries, and funeral homes.

Mary Todd Lincoln spent time in a mental hospital in Batavia called Bellevue Place. Over the years of its operation from 1867 until it closed its doors, it offered comfort, quiet, and doctors who worked to clear the patients' cob-webbed minds. It was only in the post-Civil War period that the insane came to be treated as being ill, and were not thrown into prisons. This sorting out of the old, those with mental illness, and criminals, and placing them in clean and rehabilitating institutes was particularly championed by middle and upper-class women interested in reform.

In 1860, a library association was founded in town, and by 1885 the association's collection had grown to more than four thousand books. Batavia was then, and still is today, a city of many diverse churches which offered support for immigrants who found themselves in a strange land, with a strange language, and even stranger customs. The church was an extended family helping make the transition from old country ways to "real American ways." Congregational, Baptist, Methodist, Swedish Lutheran, Episcopal, and Catholic churches dotted the hillside of early east and west Batavia. Many others followed. Their tall steeples, thrusting up over the many two-level houses and businesses in town, called out to their worshippers with joyful bells.

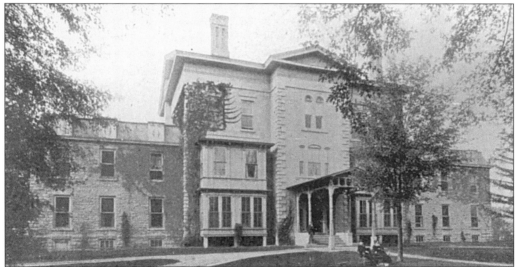

Bellevue Place was completed in 1854 to house the Batavia Institute, a private school, used until public schools were funded in Batavia. It become a private rest home in 1867. Set on 16 acres, the limestone building and grounds provided peace and quiet for the patients' recovery.

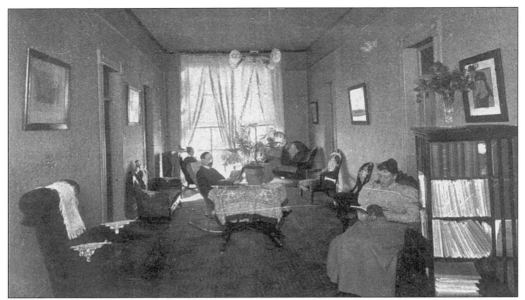

The interior of the building was well-suited to the genteel care of the patients. The wide hallways provided space for inmates to read or write. Care was given to only 20 patients at any given time.

There were rooms with barred doors for those patients who needed them, but Bellevue was known as a fine mental hospital for "refined" but mentally unstable people. Generally, the atmosphere was of a home, not a prison.

Dr. R.J. Patterson was the first physician in charge of Bellevue Place. He came to this post from being the superintendent of the Indiana State Hospital for the Insane and later the Iowa State Hospital for the Insane. It was said that he often answered the door himself when visitors rang.

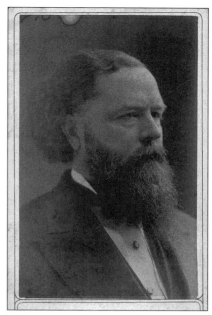

Anodyne Cough Syrup

℞. Syr. Senega — ℥ß
Syr. Tolu — ℥ij
Fl. Ext Licorice — ℥j
Fl. Ext Hyos — ℥ß
Fl. Ext Belladonna — ℥j
Sulph. Morphia Grs. ij
Tin. Aconite Rad. — ℥j

M. S. Take a teaspoonful
Every 4 or 6 hours

Asthma.
Nit Pot 4 Parts by weight
Fol. stram 2 do do
Fol. Belladon. 1 do do
Pulv. and mix — Then placed
5 to 20 grains in an
iron spoon and heat
over a lamp to com-
-bustion. Inhale the
smoke
dir med weekly

Chronic Rheumatism

R.	Potassii Iodide	2 drachms.
	Morphia sulph	2 grains.
	Tinct. aconit rad	1 drachm.
	Vin. colch	4 drachms.
	Ext. cimicifuga fld	2 ounces.
	Aq. menth pip	11 drachms.
M.	Sig.: Teaspoonful every six hours.	

Like other doctors of the time, Dr. Patterson kept his own recipes of ingredients for various ailments. Shown above is a page from his journal. He also kept his accounts payable in this book. Also shown is the top of a paper medicine box with instructions for the patient of Dr. B. to take a pill at bedtime when necessary.

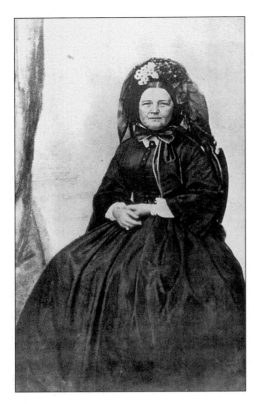

Mary Todd Lincoln was known to behave strangely when she was first lady. She was judged insane ten years after Lincoln's assassination, and was a patient at Bellevue for a short time in 1875. She was afforded a private space so that she could be alone and was treated more as a guest than a patient.

Mrs. Lincoln had rooms on the second floor and took her meals either alone or with the Patterson family who lived at Bellevue. This photograph is of her bedroom as it is displayed in the Batavia Depot Museum. The actual room would have been far more spacious.

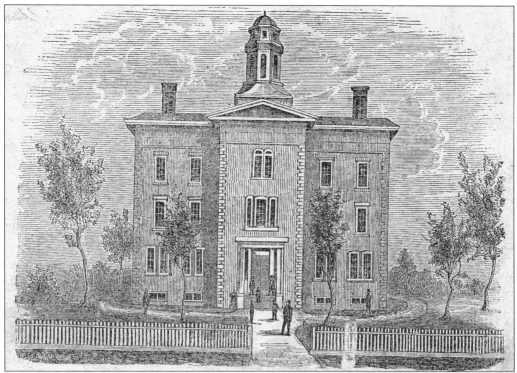

Batavia Institute was built through the efforts of Elijah S. Town, K.K. Town, John Van Nortwick, Joel McKee, and the Reverend Stephen Peet to house a private academy. Some students of the Batavia Institute adopted a resolution to form a Library Association in 1860. Books were accumulated slowly, but the association met regularly. When enough books were accumulated, they were stored in the Harvey Block and later in the Buck Block.

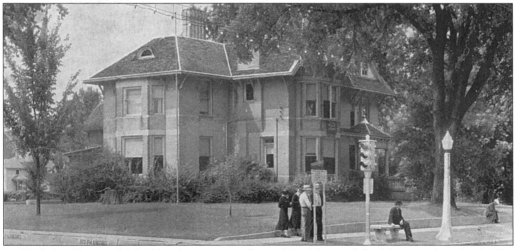

In 1885 the library of 4,346 books was moved to a Van Nortwick building on the island. The Levi Newton house at the top of Wilson Street was donated to house the collection in 1902. When that house was razed to make way for the extension of Wilson Street, the library was moved next door to the D.C. Newton house, pictured, in 1921.

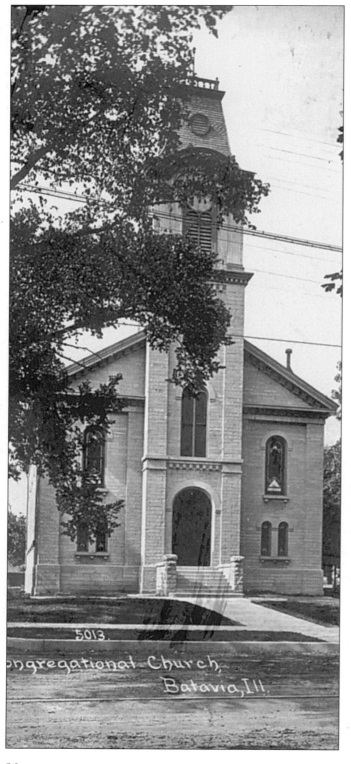

5013.

Congregational Church,
Batavia, Ill.

The Congregational Church was the first to build a permanent house of worship. They organized in 1835 as the Church of the Big and Little Woods, and the congregation went from cabin to cabin for services. They later met in the community school. The school was said to have been the first public building in the county, serving the political, religious, and social needs of the community. The building shown was paid for by subscription and built in 1855. Of the 53 subscribers, only 5 were members. This is said to have indicated the keen interest of the entire community in having this building. Their first building was shared with other denominations, especially the Baptists, and also served for a time as the district school before it was sold to the Catholic church.

The architecture of the next building (left), which is still in use, is typical New England-style, complete with a tall steeple built with native limestone. E.S. Town was the stone mason. A 2,000-pound bell was installed in the steeple in 1872, which was hit by lightning in 1887. The building was first lighted with kerosene lamps fastened to the window casings. Electric lights were installed in 1891.

From the first, the church's emphasis was on religious education for its young. Congregationalists were known for their stand against slavery as "a violation of national justice and an outrage upon humanity," according to the church's recorded history.

After using the school house, private homes, and other churches' meeting houses, the Baptists built a frame church in 1873. Later, Alex Grimes donated a lot at the corner of Wilson and Washington to build a church. The parishioners sold the parsonage, took subscriptions, put on dinners, held bazaars, and went on excursions to raise the necessary money. Grimes seems to have been the fun behind the fund raising, for he was the one who planned the excursions and drew donations with matching funds. The present building was completed in 1889.

By 1858, the Baptists were running two Sabbath Schools with one hundred teachers and scholars, two Bible classes, and had a three hundred-volume library. The Baptists also supported foreign, home, and domestic missions. The Baptists started a Sunday School in 1835, and are credited with having the first such instruction in Kane County. By 1873, the Sabbath School had nearly two hundred participants. Before the Baptists had a building, baptisms were held in the Fox River. In winter, they would chop out a block of ice to make a hole big enough to baptize new members.

This Romanesque Revival church was a gift to the Methodist church by Captain Don Carlos Newton and the Reverend Elijah H. Gammon, who was once a minister of the congregation. Captain Newton took a photograph of a church he visited in France, and architect Solon Spencer Beman designed the Batavia church modeled after the French church. It differs from the French in the use of field boulders within the walls.

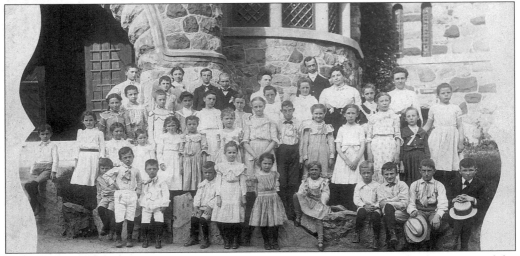

These children are posed for their Bible school, or catechism, picture on the front steps of the church sometime between 1900 and 1905. Boys and girls were dressed as "little adults," but with shorter pants and skirts until the age of 12 or so. All those ruffles were ironed with heavy irons; no drip-drys here.

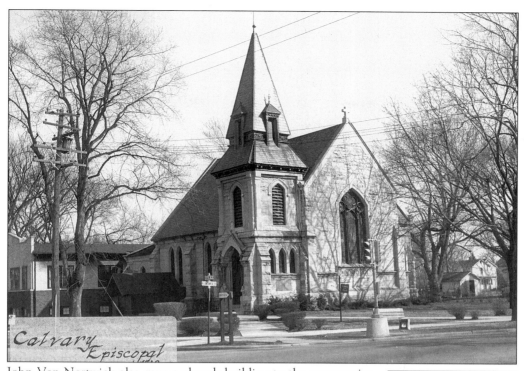

Calvary Episcopal

John Van Nortwick also gave a church building to the community in 1879. The Episcopal congregation's first church had been destroyed by the 1856 tornado, and they met in members' homes until this church was built. The first Episcopal services were held in 1842, in the home of Mrs. James Derby.

This window was a gift to the Calvary Episcopal Church in memory of Theodora Towner Van Nortwick, infant daughter of John and sister of Louise. It is matched by a window depicting a standing Mary holding Jesus, which was given in memory of Louise Van Nortwick Goff (1865–1866). These high Victorian stained-glass windows are on the south side of the sanctuary.

LUTHERAN CHURCH, BATAVIA, ILL.

The Swedish immigrants who settled in Batavia came mainly from a few neighboring parishes in Halland, Sweden. They went to Geneva to worship until 1872, when they formed a Batavia church and bought a former school for their first place of worship. In 1887, the small church was torn down and replaced with a red brick church with a tall steeple. Bethany Lutheran Church was later rebuilt as the present church.

Swedish was the original language of Bethany Lutheran Church. Through the end of World War I, children attended summer Swedish school to learn their Catechism and Bible history in Swedish. A weekly Swedish service was held until the end of World War II. The young people below were members of the confirmation class of June 9, 1907. Their names are listed on the original photograph, which is in the archives of the Batavia Historical Society.

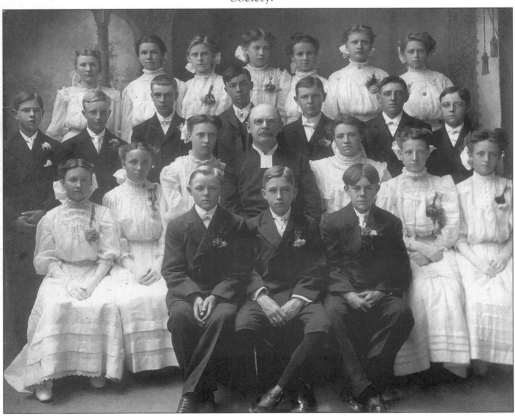

Holy Cross Catholic Church was organized in 1846, but the first masses were celebrated by a priest in parishioners' homes in 1845. Before they built the above church in 1897, they used parishioners' homes and then the wooden church built by the Congregationalists.

Historian John Gustafson describes some hard times the church had in building a new church. He said parishioners were hard hit by the Depression of 1896. Instead of money, they donated materials and labor for the construction of the church. Parishioner William Shannon and his former laborers qu*arried Shannon stone, and then cut, dressed, and set it. The ecumenical sharing in Batavia was demonstrated once again when non-Catholics helped the church make payments on their first home and donated the bell for the building above.

George H. Burnett was born in Batavia in 1870, as was his mother before him. After the completion of his education in Batavia, he attended the Champion College of Embalming in Cincinnati, then studied in Chicago, and passed an examination to become one of the first individuals to earn a state embalmer's license. In 1897, he became an embalmer and funeral director in Batavia.

This house was built for the J.P. Prindle family in 1885, but it was later sold to Hollister Funeral Company in 1917, complete with furnishings and draperies. The first floor was well-suited for public rooms. The basement housed the work area, and the family lived upstairs. It is located on the southwest corner of Wilson and Batavia Avenues.

Eight

A BATAVIA MID-1800s WALKING TOUR

Log cabins were the first shelters to be used by the pioneers in the Fox Valley. None of these are still standing. Also lost to us are the homes of Levi Newton and William and John Van Nortwick. The Newton home on Batavia Avenue was destroyed when Wilson Avenue was continued west. The Van Nortwick homes were located on South Batavia Avenue and were destroyed years ago to make room for the high school. However, many of the early houses built between the late 1840s and the mid-1860s are still in use. Most of these are frame houses, built with wood from the Big or Little Woods. A few are constructed from native limestone. The majority of the early structures are simple, Greek Revival-style houses along with a few cottages. The more elaborate Italian influence was ushered in by Joel McKee. Watch for the Swiss and Gothic influences as well. The best way to see the details of the houses is on foot, but a bicycle or an auto tour is also possible.

Not included in this tour are the two and three-story post-Civil War wooden houses, with fancy turrets and multi-colored exteriors. These were built to impress and became homes for the new rich of Batavia. They were decorated outside and inside to excess and have come to be called "painted ladies." Batavia has an abundance of such homes, and they have been included in other walking tours of the city. The narratives for these tours are available at the Depot Museum and the Batavia Public Library.

Now, let's begin our tour of 21 mid-1800s Batavia homes.

Early Batavia saw settlement on both sides of the river. This tour begins in west Batavia and concludes in east Batavia. Some early houses that are still standing are missing from this tour, because they are featured in other chapters. All except one of the houses on this tour continue to be used as homes, and that one houses a home-based business.

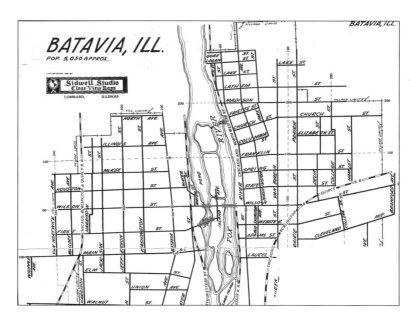

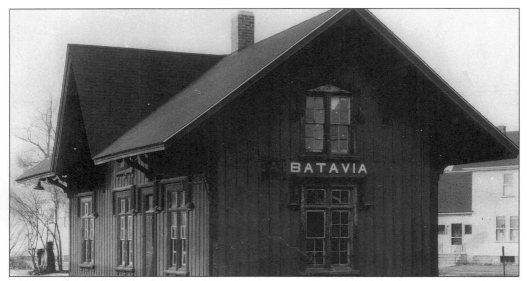

We begin at 155 Houston Street. The Depot Museum, a good place to begin the tour, was an 1854 French Gothic CB&Q rail station, which was moved to the present location to house the historic artifacts of Batavia. This depot is the oldest surviving Burlington Railroad depot in the United States.

Stop two is 345 North Batavia Avenue. This Italianate-style house, which sits high on a hill overlooking the Fox River, was built in 1852 for Joel McKee, one of the earliest settlers in Batavia. McKee had a hand in starting many businesses in the early years, among the first being a general store and a mill.

Stop three is 21 North Lincoln Avenue. This 1856 simplified Italianate-style house had a belvedere on the roof, which has been replaced by a square railing. Compare it to the house on the previous page. The proportions are similar, but the house is both shorter and narrower and has less ornamentation than the previous one.

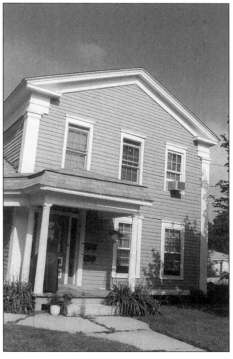

Stop four is 27 South Lincoln Avenue. This 1850 Greek Revival house was once the home of tailors Davis and Tincknell, who came to Batavia from England. Davis also owned a secondhand shop. As late as 1910, this house had no indoor plumbing. There is an addition to the left and on the front, which destroys the symmetry of the original style of this house.

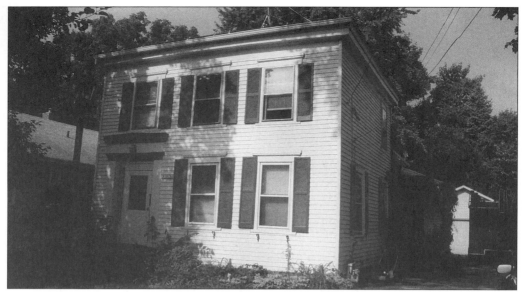

Stop five is 111 South Lincoln Avenue. Frank K. George is the best remembered owner of this 1850 Federal-style house. He came to Batavia in 1865, and sold insurance and real estate for 19 years. In 1877, he and his sons also established a bakery and grocery store.

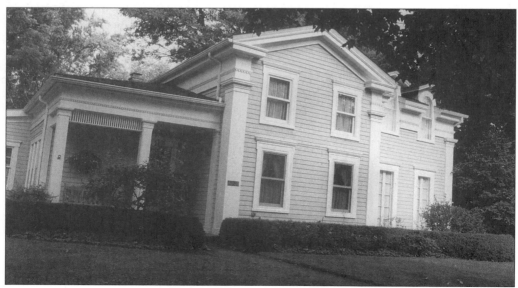

Stop six is 125 South Lincoln Avenue. This 1852 Greek Revival home was bought in 1863 by John Burnham, partner of Dan Halladay. Burnham was the one who went to Chicago to convince John Van Nortwick to use the Halladay windmill to pump water for railroad engines. Like several other Batavia houses, Burnham had a windmill on the property.

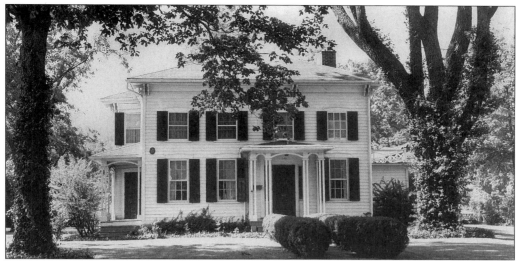

Stop seven is 350 Main Street. This 1855 house was once the home of Judge Thomas C Moore, who was a friend of Abraham Lincoln. He lived in Batavia from 1848 to 1892, and is one of many men the Fox Valley credited with helping to form the Republican Party.

Stop eight is 415 Main Street. This 1860 Italianate house was the home of a Spooner family, who was related to Halladay through marriage. The shutters and "eyebrows" were made to surround curved windows. The square windows are probably replacements for the original curved windows. In the 1860s, curved windows were thought to be more graceful than the rectangle ones of the Greek Revival period.

Stop nine is 432 Main Street. In 1863, Daniel Halladay moved to this Greek Revival home which had been built in 1850. His self-governing wind engine was ranked as one of the most useful inventions of his age.

Stop ten is 505 Main Street. This 1858 Queen Anne-style house reminds many Batavians of a Swiss chalet. It was once owned by Dr. D.K. Town, who practiced medicine and later sold real estate in Batavia. A later owner was Captain Leonard J. Carr, a retired sea captain who had moved to the Batavia area in 1839.

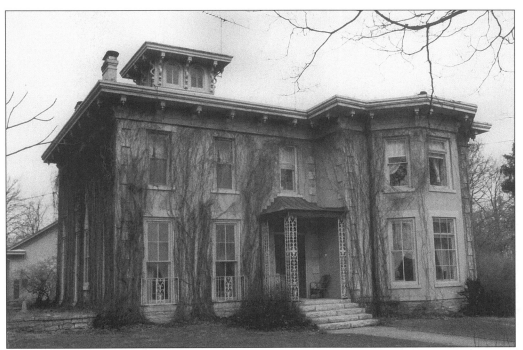

Stop 11 is 419 Union Avenue. The western portion of this Italianate-style house was built in 1863 by E.H. Ferris. In 1886, Dr. R. Patterson, who ran Bellevue, purchased the house and built an addition on the east side, nearly doubling the size. He and his family had lived in Bellevue before they moved here.

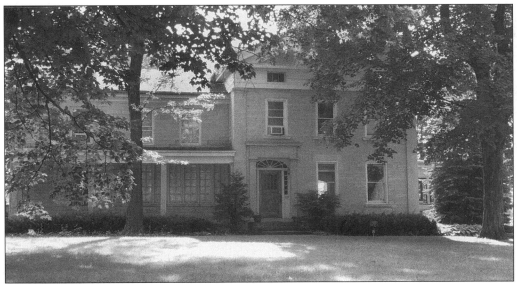

Stop 12 is 528 South Batavia Avenue. This 1849 Greek Revival house was built by Elijah Town and was sold in 1853 to Judge Lockwood, land agent for Illinois Central Railroad. He in turn sold it to his son-in-law, William Coffin, who opened Batavia's first bank in a frame building next door. Theodore Snow of the Challenge Company was a later owner.

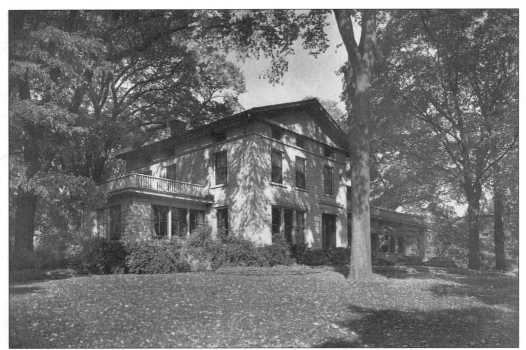

Stop 13 is 825 South Batavia Avenue. This 1849 Greek Revival house was built by Elijah S. Town as Judge Lockwood's residence. It is known as Lockwood Hall. Later, Rodney Brandon, an early 1900s Illinois legislator, lived here. Both Brandon and Ernest M Oswalt of Campana are credited with helping bring Mooseheart to the area south of Lockwood Hall.

Stop 14 is 239 East Wilson Street. This cottage-style home of General Thompson Mead, who commanded the New York State Militia's Seventeenth Regiment in the War of 1812 was built in 1850. There are hollyhocks flowering behind the picket fence today, just as there were in the earlier years.

Stop 15 is 406 East Wilson Street. You must look carefully to see what may be the oldest known house still standing in Batavia. Judge Isaac Wilson built this house, and moved here from the Payne cabin in 1843. Judge Wilson changed the name of the town from Big Woods to Batavia, after Batavia, NY, and Wilson Street is named for him.

Stop 16 is 117 South Prairie Street. This 1860 cottage was built of rough-cut limestone and has smooth window lintels and sills, and quoins, or external, cornerstones. Stone and wood cottages were the homes of Batavia's blue-collar and white-collar workers.

Stop 17 is 123 North Prairie Street. H.E. George once lived in this 1862 Italianate house. He was the recorder of Kane County in 1912. The lintel keystones over the windows are a departure from the traditional Italianate style. This building style seems to have been the choice of up-and-coming Batavia citizens at the time of the Civil War.

Stop 18 is 312 Spring Street. This 1852 Greek Revival house was built by A.W. Bull using limestone, a inexpensive local building material. Even the lintel above the front door and the window sills are of stone.

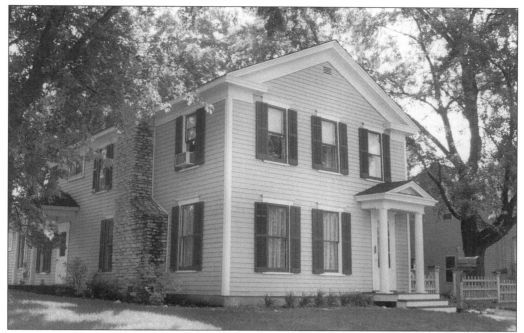

Stop 19 is 328 North Washington Avenue. This was the 1819 Greek Revival home of Louise White. She was a granddaughter of the Condes, whose home was located at 210 North Washington. She was a much beloved educator. The school where she was a student and later a teacher was named after her.

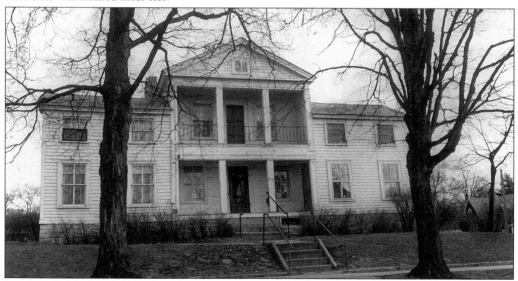

Stop 20 is 210 North Washington Avenue. This Greek Revival house was built for the Conde family in 1849. Blacksmith Cornelius B. Conde was the first member of his family in Batavia. He and his wife, Hannah, and their two children moved to Batavia from DuPage County in 1842. By 1849, there were seven children, who became early entrepreneurs, selling candy and making gloves, mittens, and robes from fur pelts. Conde descendants continue to live in this house.

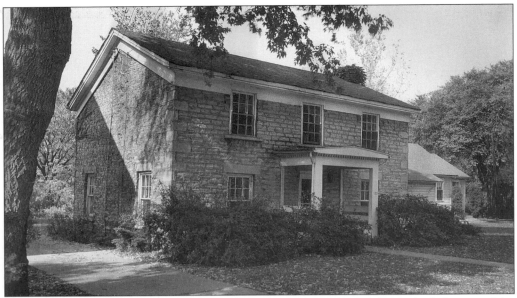

Stop 21 is 123 North Washington. This adaptation of the Federal style was built by one of the Schimelphening boys, who moved from the family farm into town. Use of limestone was once again a departure from the use of brick, as were as the long, low windows on the south side.

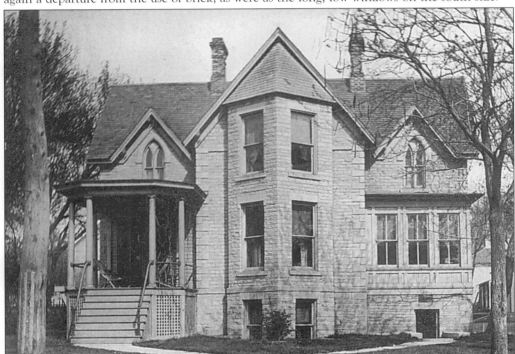

Stop 22 is 114 North Washington Avenue. This 1865 Gothic-style house once housed the east-side branch of the Batavia Public Library in its basement. Dr. DuFour , a contemporary of Col. Fabyan, operated a small private hospital in his residence while he lived here. This concludes our look at 22 of Batavia's early landmark buildings.

Nine
THE FINEST TOILET GOODS FACTORY IN THE WORLD

The Industrial Age in the post-Civil War period focused on a better communication and delivery system for goods from coast to coast. Local manufacturers increased their factory output by using new labor-saving machinery and marketed their goods far and wide.

This increase of business also had a negative impact locally. Local flour mills, which had counted on a steady and captive market for their goods for years, suddenly had to compete with flour processed and packaged outside of their area in the local stores. How do you sell a product when there are countless other products just like your own? Newspapers all across the country began to include ads for products. Logos and trade names were developed, and labels were applied to sell the product. Industrial mass production of goods thus created mass advertising as a means of selling all the products that factories were churning out at an ever-increasing rate.

Patent medicines began to be sold in the pharmacist's store. All had catchy names and colorful slogans, such as "pink pills for pale people." Most of the curative remedies made ridiculous claims, many of which claimed that the ingredients were based on Native American secret cures. "Sell, sell, sell, any way you can," became the watchwords of the decades at the end of the century.

By the 1920s, merchandising and retailing had reached new heights. Psychology was used to create slick ads for products, and producers noted how packaging could be used to sell. Streamlined, Art Deco-style products were all the rage. In Aurora, the Burlington Railroad produced sleek new passenger trains that became immensely popular because of their new shape. The Elgin Watch Company streamlined their cases as well.

Batavia became the home of a most impressive factory built in the valley during the waning years of the Depression. The Campana Company building (1937) was cleverly designed to be as functional as it was strikingly beautiful. Slick marketing ensured that the public was searching for products manufactured by this futuristic U.S. and Canadian-based company.

The typical patent medicine sold through the mail in 1917 was Zaegel's Essence and Lung Balsam. The Essence claimed to cure rheumatism, stomach, liver, bowel, and kidney complaints. The Lung Balsam was sold as a cure for coughs, lung and throat troubles, and whooping cough. It was also touted to be effective when used in connection with Essence as a cure for consumption.

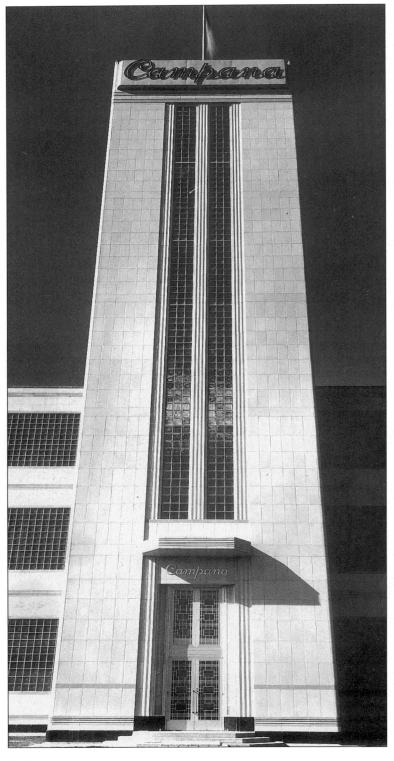

Campana, the name of the company, originated from Dr. Campana, a Canadian who had developed a product called Italian Balm. Ernest M. Oswalt of Batavia purchased the trademark and rights to this product. Campana was authorized to do business in Illinois in February of 1927, and the company began manufacturing Italian Balm in the Household Journal Building on the corner of Batavia Avenue and First Street in 1928, then moved to their new home in 1937.

This building is a breathtaking example of the new school of architecture that developed after World War I. Simplicity of design was the watchword-streamline it. This long, ground-hungry building is as sleek-looking as the Burlington *Zephyr*, and the mini-skyscraper tower added a masculine touch of importance.

Once they entered through the doors at the base of the tall tower at the center of the factory, visitors found themselves in a lobby glowing in diffused light with a streamlined staircase. Campana advertised the building in lush terms, "Sunlight streams in through glass brick walls to every nook and corner. Sparkling equipment greets the eye through plate glass, chromium-trimmed partitions. Specially designed from powder room to observation tower, Campana's new home. . . is the last word in technical perfection."

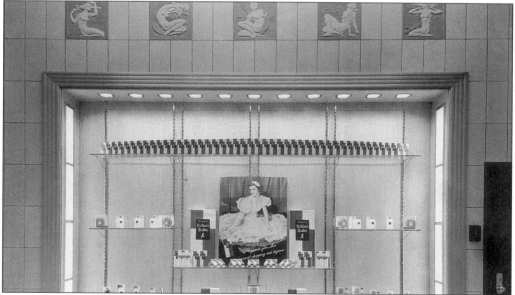

The female nude terra cotta sculptures over the display case in the lobby call attention to the fact that Campana products were mainly aimed at beautifying women. The young lady in this photo is advertising Italian Balm. Once Max Factor made the make-up products he designed for Hollywood stars available to America's women, a new American industry was created. Campana marketed a wide range of toiletries. After World War II, the company was one of the first to market a dietary product, caramel candy no less, called Ayds. Machinery could produce Ayds at a rate of 104 per minute.

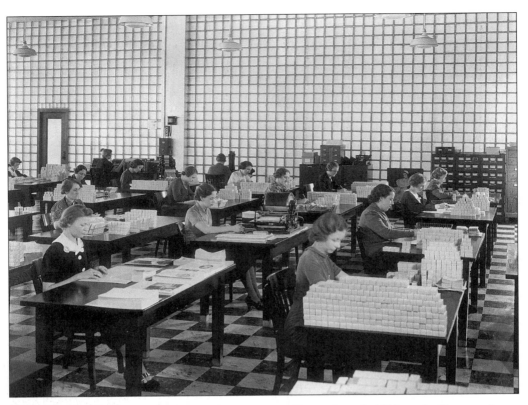

Here is 9-to-5, 1930s style. Dozens of young women corresponded with Campana's millions of customers. One million samples of Dreskin Italian Balm (skin softener) were mailed out during the late 1930s and early 1940s. The women here are applying mailing labels to the sampler boxes going out to potential paying customers. Anne Carlson, from Elburn, worked on the line putting labels on the bottles. Overhead lights and a wall of diffused exterior light bathe the room.

Interior hallways in the building were also partially lit through glass bricks, which let in secondary light from the exterior rooms with natural wall lighting. When it was first built, there was trouble with the terra cotta, and some sections of the unique glass blocks had to be removed. This was reportedly the first structure in the U.S. to use glass building blocks. This building designer wanted to capture as much natural light as possible.

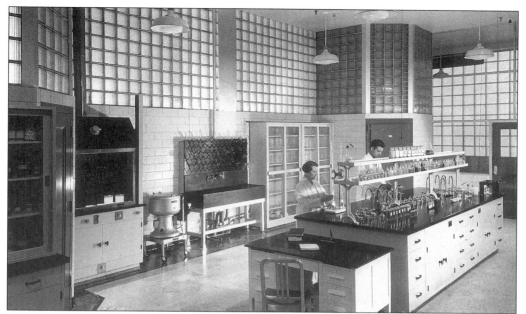

The two chemists in the Control and Research lab constantly checked and tested each batch of the product to insure quality. The samples were taken from the mixing tanks in another part of the factory. Cabinets and as much equipment as possible were made of streamlined metal for sanitary and fire protection reasons.

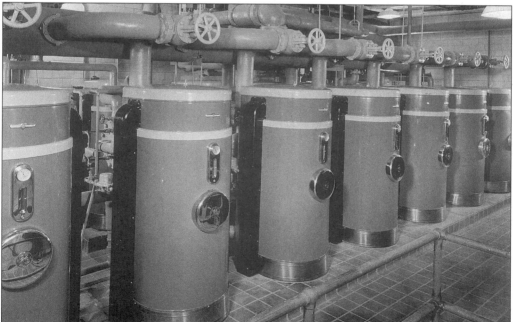

Many special tank containers were used throughout the Campana plant to store, mix, and homogenize various ingredients. These tanks were specially made by General Electric and had very precise temperature controls. This series of mixing tanks had the look of a modern mini-brewery room. Any spills of liquids onto the ceramic floor could be easily mopped up.

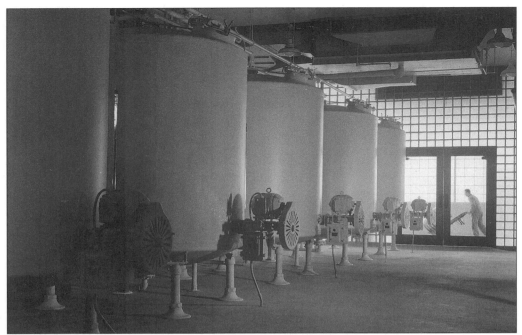

These tanks were used to age both the Italian Balm and the Dreskin Formula. They maintained a consistent 70 degrees and were filled automatically. This photograph of the worker transporting a barrel of liquid in the hallway outside this room on the second floor of the building is a beautiful artistic study of different shades of light.

The preliminary mixing tanks were located on the third floor. From here they were gravity-fed to the mixers below by a photo electric eye control, something quite new in the factories of the 1930s. The huge Toledo weight machines by the tanks were carefully controlled from the master console shown on the left.

The final mixers were located beneath storage and mixing tanks, and resembled a railroad turntable. All operations were automatic, and the six mixing tanks were glass-lined. The overhead tanks directed the product into one of the six tanks mounted on the floor, which revolved to facilitate filing. This room, and many other such rooms in Campana, looked more like a hospital than a factory. Natural lighting and some drop electric lights kept this room well lit.

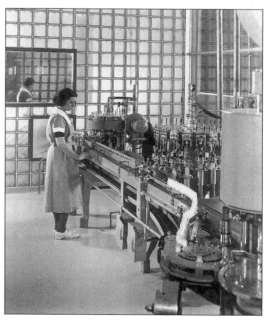

The final product was now ready for packaging. A worker here is carefully overseeing the filling of bottles. These are probably $1 bottles of Campana's "Dreskin—the original skin invigorator." Each such line in the plant could fill 70 bottles a minute. In 1938, Campana had 3 million special metal dispensers in public places, which held bottles of this product.

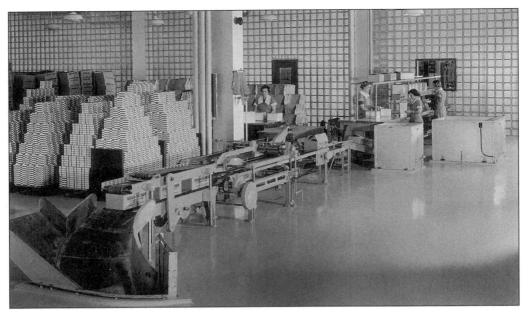

The bottles were conveyed into another room to be packed into boxes and stacked in pyramid fashion. From these stacks, orders would be filled and placed into shipping cartons by workers. Here they were placed on a stainless steel conveyor system that used gravity to feed them down to the bottom floor of the plant. Marion Swanson Todd of Batavia went to work for the young company early on. Her job was to "drop Italian Balm," meaning to put the bottles into the crates.

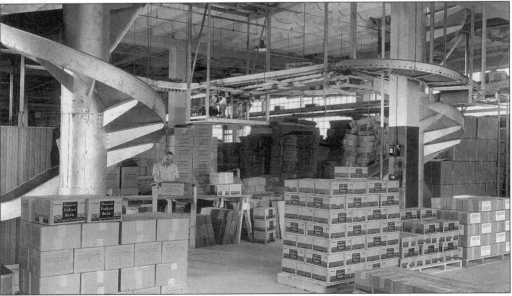

The spiral gravity feed system resembles children's playground slides and airport luggage delivery systems of today. Workers used forklifts to move the loaded skids of Italian Balm, shown here, to await shipment to dealers. Whether you were the secretary to the vice president or working on the floor, wages were about the same for women—$12 per week in the waning years of the Great Depression. Men earned a few dollars more.

The mixing of ingredients, the bottling, and the exit of the product onto railroad cars directly behind the factory was sheer poetry in motion. In cold weather, the huge overhead door could be kept closed and the boxes delivered into the boxcars through a smaller opening at the base of the doors. Campana had its own delivery trucks as well.

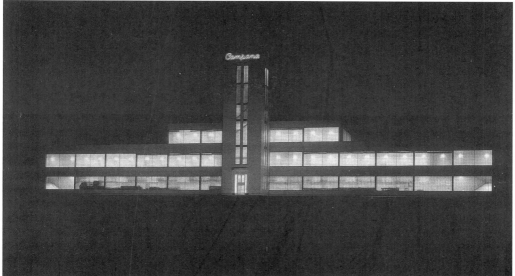

The Campana building illuminated at night was a sight to behold. The company's lighted sign could be seen for miles, and the windowless factory seemed to come alive and glow with light. The Campana building stands as living proof today that factories do not need to be ugly and inhumane places to work. The company's catalogue sent to its dealers noted that "Working in Campana at the time must have been like playing in Stock's Chicago Symphony. . . part of a glorious life experience."

A high-tech factory capable of cranking out products efficiently and quickly is not much good unless you can sell them. Campana was one of the companies that wrote the book on how to do this in the 1930s and 1940s. In 1938, their jubilee year, they initiated a marketing plan to make sure that every man, woman, and child knew about their products. They barraged the public with advertisements in women's magazines, standard monthlies, farm papers, weeklies, and professional papers aimed at all social classes.

They called upon their dealers and asked the public, through ads in publications and their own Campana radio programs, to send in their names. The names would be compiled and bound in a huge Italian leather book called the *Honor Roll of Customers* and displayed in the plant's "Visitor Galley" for all to see.

First Nighter was a drama show on radio in the 1930s, sponsored by Campana, that had 57 percent of radio set owners as listeners (10 million). It featured actor McDonald Carey as host, with Barbara Luddy as "*First Nighter*'s Leading Lady." Campana launched another radio show coast-to-coast on Monday nights at 8:30 pm on the NBC Blue network called *Campana Varieties*. The program featured Hollywood gossip by Sheilah Graham.

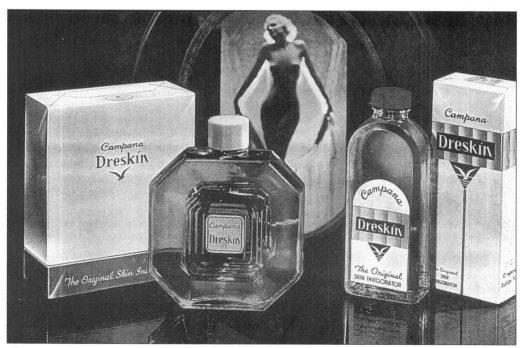

The company also began test campaigns to determine what was the most effective way to deliver customers. They found that when sending a free sample of Italian Balm, one of their biggest sellers, 80 percent of customers would continue to use the product. They especially liked to use "punch messages" in their radio ads and on movie screens. Copy advertising also delivered their version of "punch messages." Notice the shapely "nude" in the background of this ad which appeared in women's magazines promoting Dreskin.

The company added lipstick to its product line in 1940. When Campana entered the World War II years, it dropped the word "Italian" from its "Italian Balm" product, and the name changed to "Campana Balm." The company was limited in how much it could produce for consumers. It made products for the government Chemical Warfare Services that could be used as ointment for soldiers who received burns. They were called M-4 and M-5, and were packaged in tubes. After the war, business did not go well for Campana. Sadly, sales began to slip, "kaboom," as Ben Oswalt noted. They added the word "Italian" back into the name of the product that had been the backbone of company sales, but even this did not help.

Ernest Oswalt (above) died in 1955, and the next year the company was sold to Allied Laboratories from St Louis. Purex Corporation bought Campana in 1962, and operated the company for 20 years before the factory was closed and sold. This dream of a factory lasted little more than half a century! But this beautifully designed building still exists, as does Oswald's personal residence at 717 North Batavia Avenue.

INDEX

On pages 58, 62, and 64, Fred Krause was able to climb a ladder, hold a barrel, and float in front of a wall by wrapping his two hands around an oval ring attached to the wall and secured with a nut and bolt.